THE HOLLOW OF THE HAND

THE HOLLOW OF THE HAND

PJ Harvey & Seamus Murphy

BLOOMSBURY CIRCUS

LONDON • OXFORD • NEW YORK • NEW DELHI • SYDNEY

Contents

Washington DC

Kosovo

On a dirt road

we drove up the mountain
turned off the engine

climbed through a barricade
and walked towards the village

through a thousand fallen plums
the purple-black flesh

pushing out of their open skins
darkening the road.

The Abandoned Village

I thought I saw a young girl
between two pock-marked walls.

I looked for her in the white house
that crumbled mud from its falling roof.

On a nail in the kitchen
a threadbare apron.

The husk of a corn doll
hung from the ceiling.

I asked the doll what it had seen
I asked the doll what it had seen

I looked for the girl upstairs. Found
a comb, dried flowers, a ball of red wool

unravelling. A plum tree grew through the window,
on the window ledge a photograph

in black and white, but her mouth is missing,
perished and flaked to a white nothing.

I asked the tree what it had seen
I asked the tree what it had seen

Zagorka

An old woman stands
in the middle of a track.
She holds two silver keys
behind her back
on a chain, and brings them
together and apart again
with oddly smooth fingers.
She shows us the river
where she used to hear
children's voices.
I follow her and wait
for words to be translated.
She talks of a circle which is broken.

In the heat the stone wall tilts.
Black and white posters
of the recent dead
are nailed to wooden stakes
beside the locked church.
We ask but she won't let us in.
Both keys move into a fist.
A dog barks in the distance.
The hills rise up before us,
a curved and broken line
at the border.

Chain of Keys

Fifteen keys hang on a chain.
The chain is old and forms a ring.
The ring is in a woman's hand.
She's walking on the dusty ground.
The dusty ground's a dead-end track.
The neighbours won't be coming back.

Fifteen gardens overgrown.
Fifteen houses falling down.
Numbers painted on the doors,
posters on the locked-up church
in black and white, the recent dead.
Now all I do is wait, *she says.*

The woman's old and dressed in black.
She keeps her hands behind her back,
slips the keys along the chain,
worries them and worries them.
Imagine what her eyes have seen.
We ask but she won't let us in.

A key so simple and so small;
how can it mean no chance at all?
A key – a promise, or a wish;
how can it mean such hopelessness?
Now all I do is wait, *she says.*
Now all I do is wait, *she says.*

Dance on the Mountain

Boys crouch
on the slopes of dry grass
to watch their fathers dance.

The oldest dancer
removes his white felt hat
to place a glass of water

on his head.
He tramples the ground, he bares his teeth.
He wants to wake the dead.

In the terrible heat
the drums become louder and faster.
Some water spills

as he kneels
before the village elder,
dark stains on his shirt.

Then he stands
to pass the glass
to his eldest son.

The Railway Station

Where have they gone?
Nobody knows

not the Romany mother
or the child with the chicken

or the three policemen
in the bar, who fall silent

not the somersaulting boy
who spins on the pavement

or the overweight guard
who raises his voice

and his red shirt
to show us his scars

 ★

A young man in stone-washed jeans
drifts across the railway track

Box cars stand in rows
sliding doors rusted open

black vaults
rank with urine

A thin line of daisies runs
through a crack in platform one

Where it begins

a revolving wheel
of metal chairs

hung on chains
squeals in the heat

Four children fly
over red dirt

A cassette tape
of a sad song

loud and harsh
from a truck

The chairs blur
and form a ring

that ends
where it begins

Pity for the Old Road

'There was a beautiful old road
trees on both sides

but they put the trees away
and they built the houses

Pity for the old road
and for the trees on the right and left side

In my childhood we are taking this road
always to go down by the river

and to love swimming
and coming back late in the evening

I still have the smell in my nose.
It was dusty, and the trees. . .

I am recognising that a lot of time
has passed through since I left

Some things are never gonna come back again
and not that it's making me sad

It's quite a normal process
but it's giving a bit of a feeling'

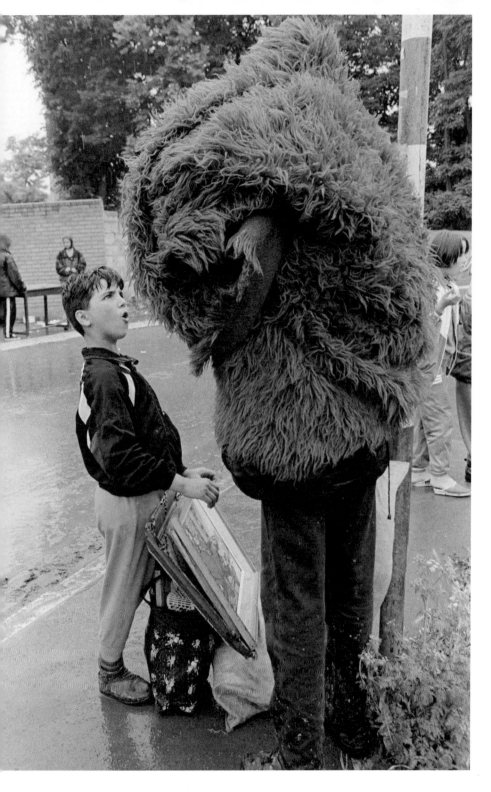

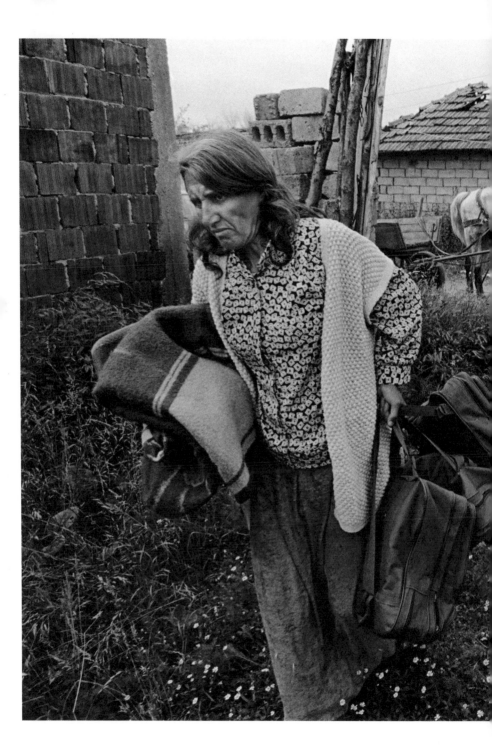

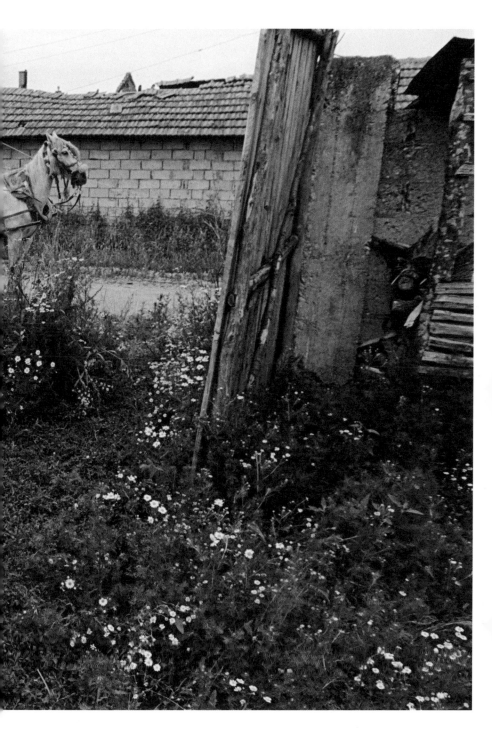

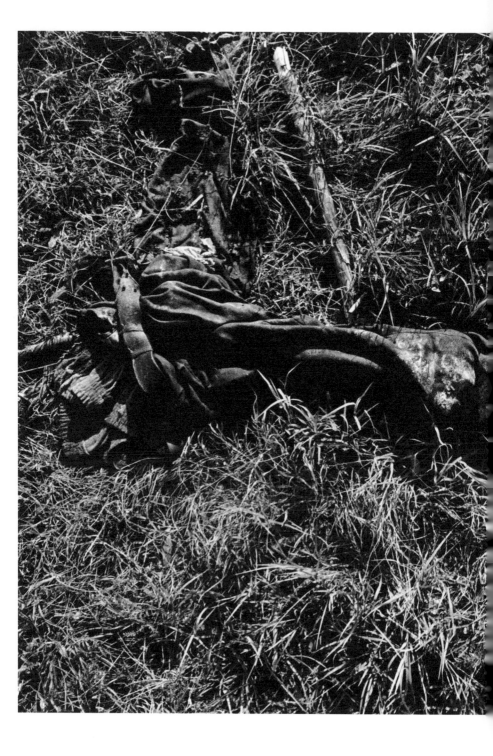

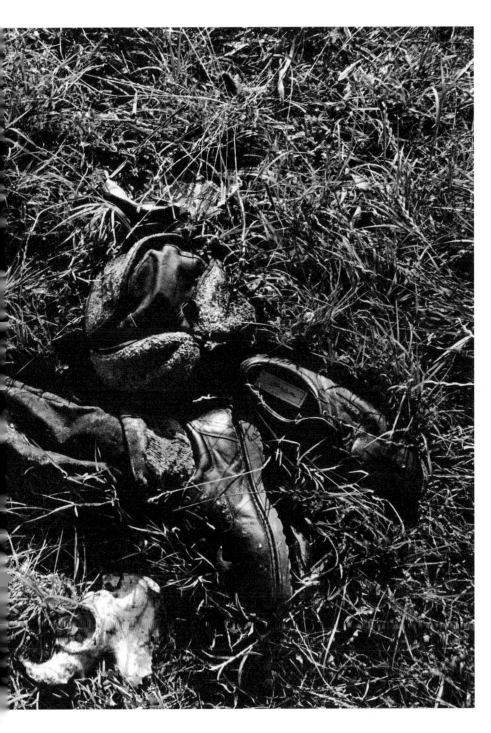

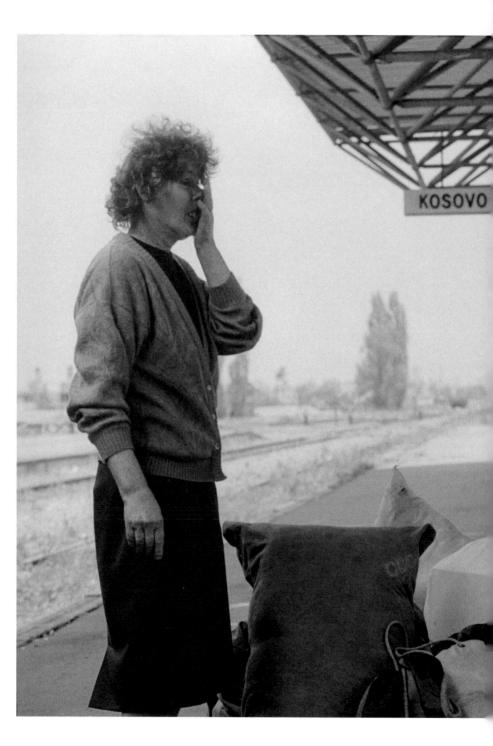

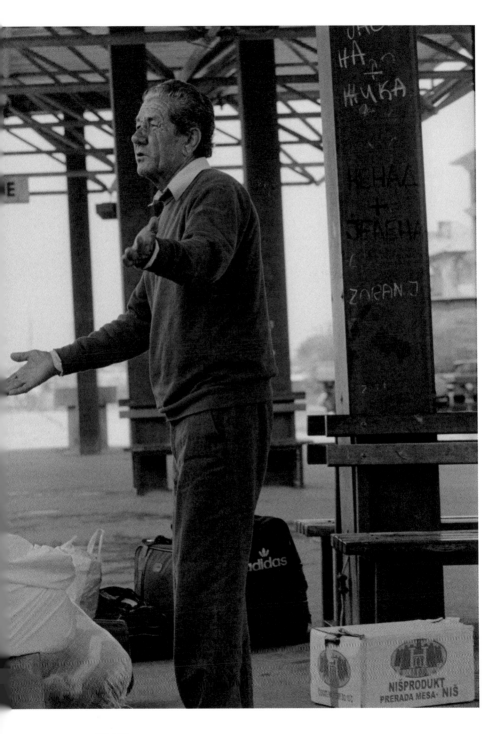

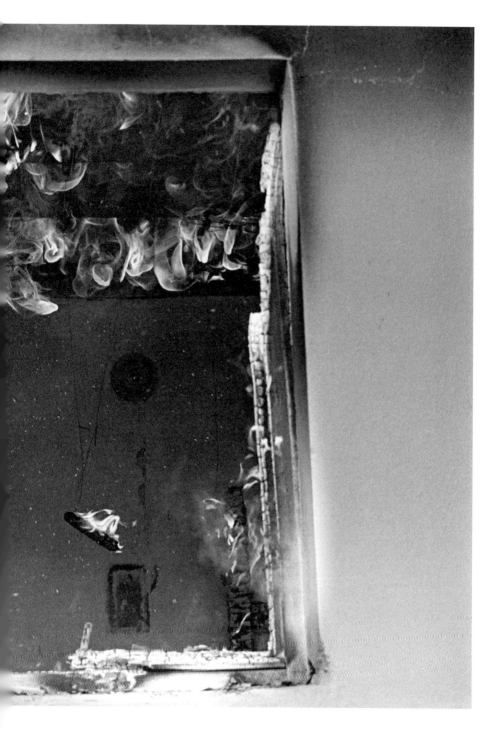

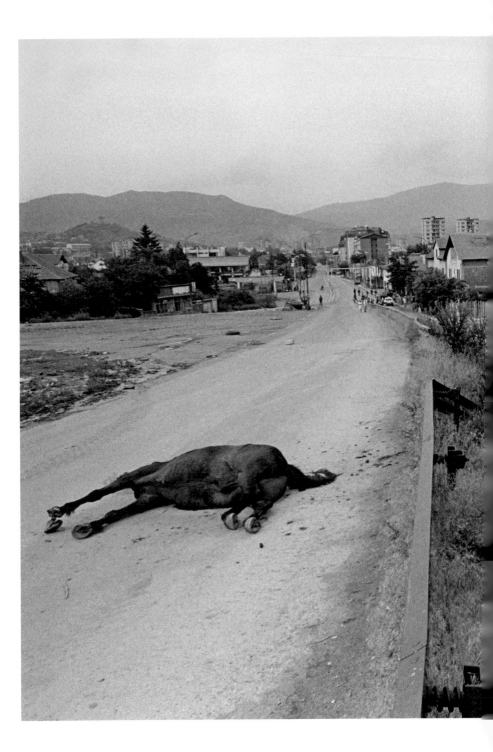

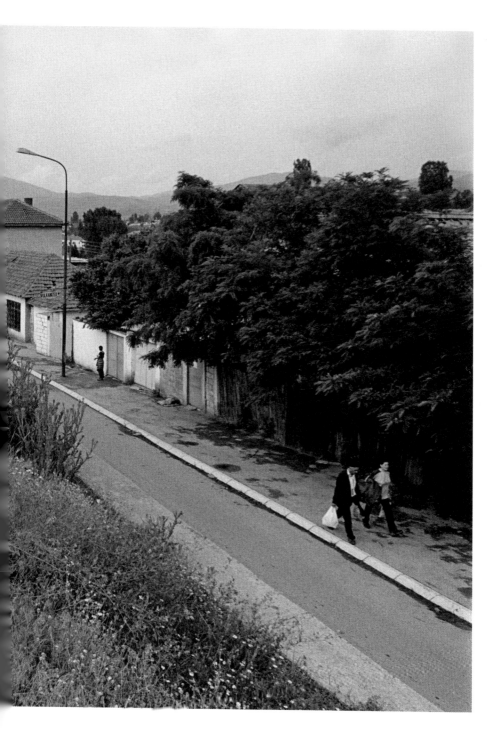

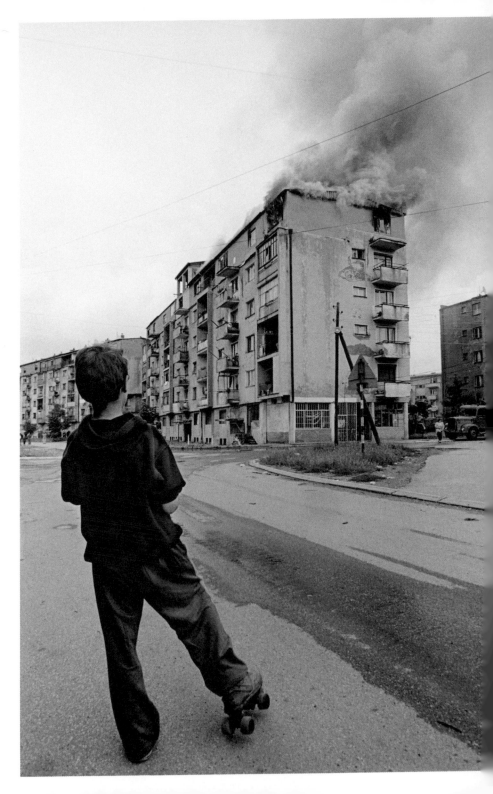

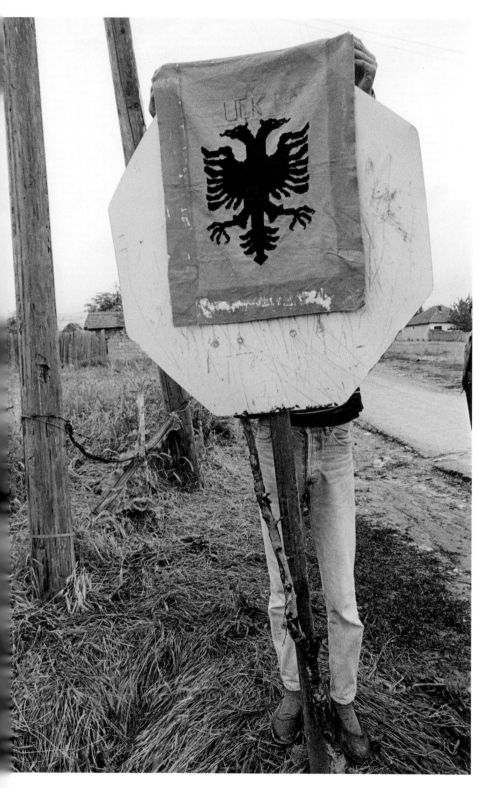

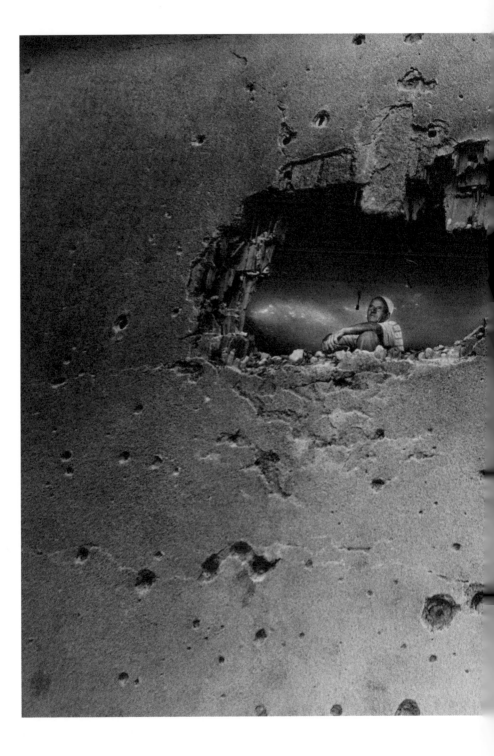

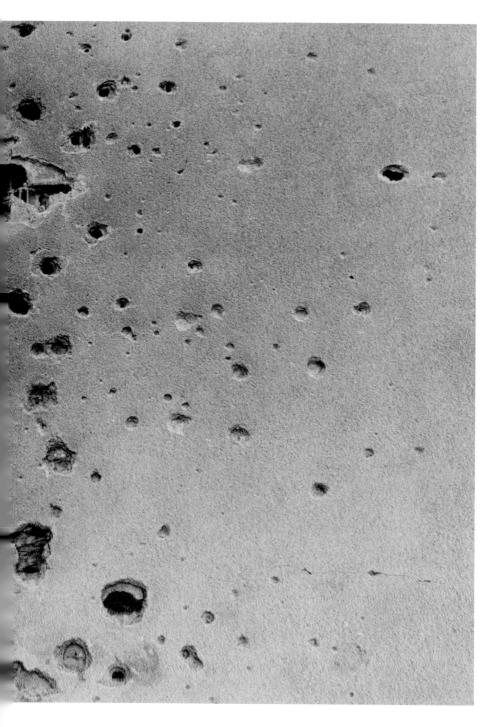

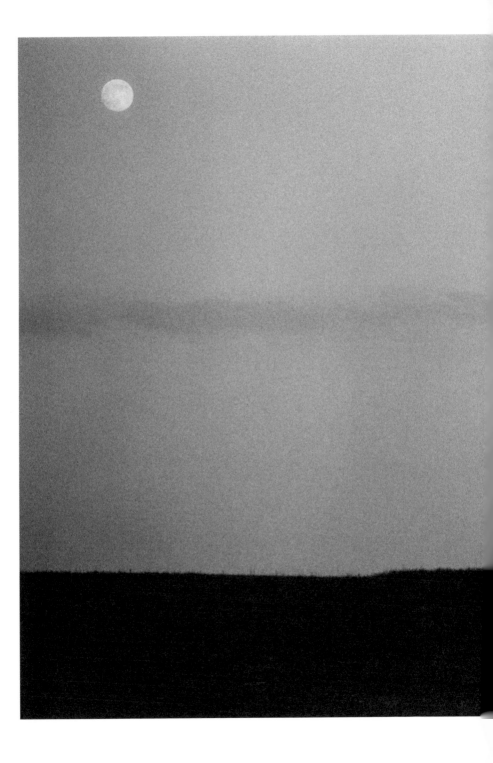

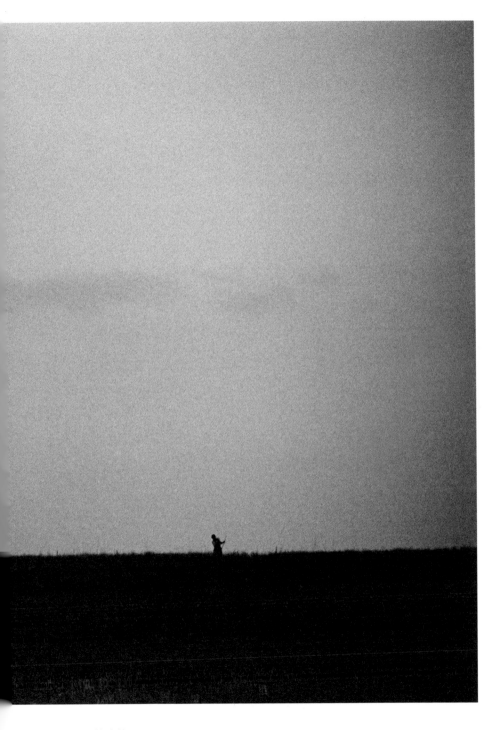

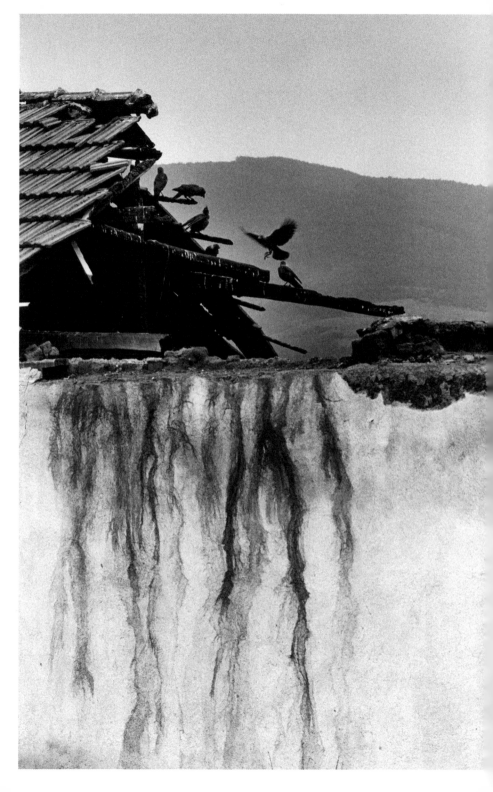

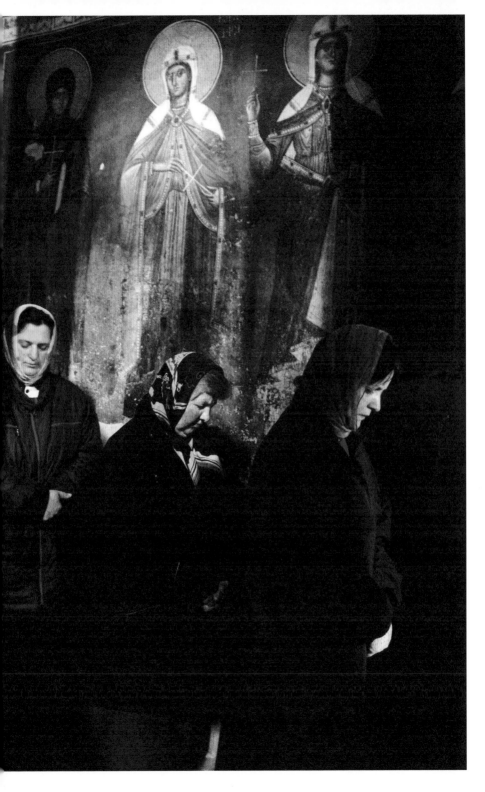

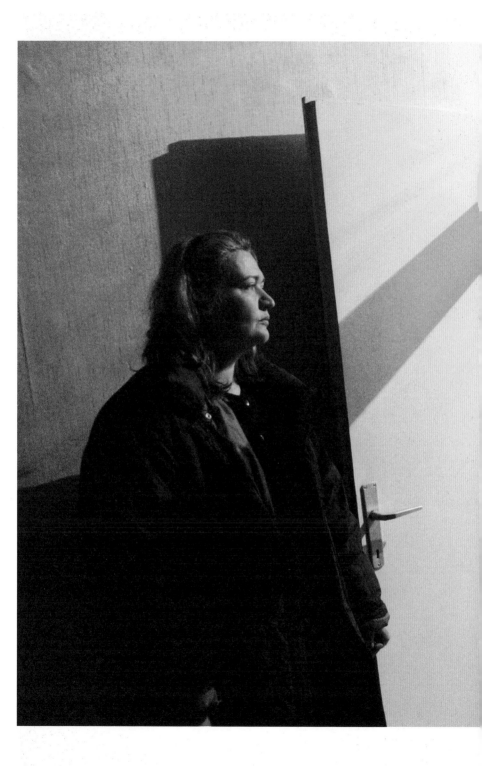

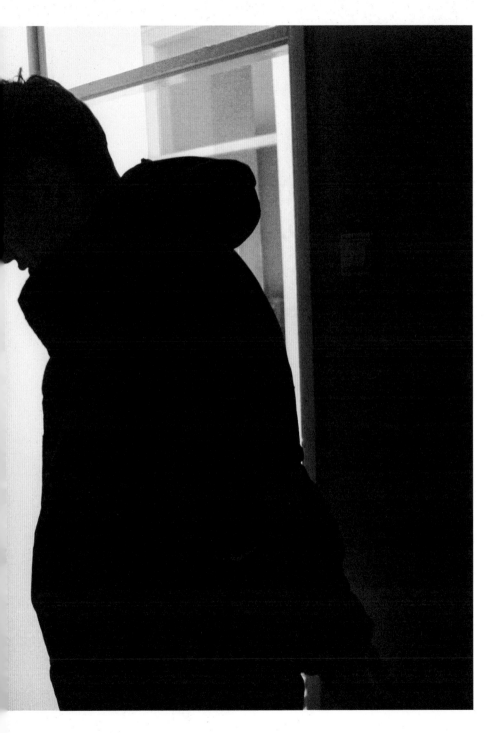

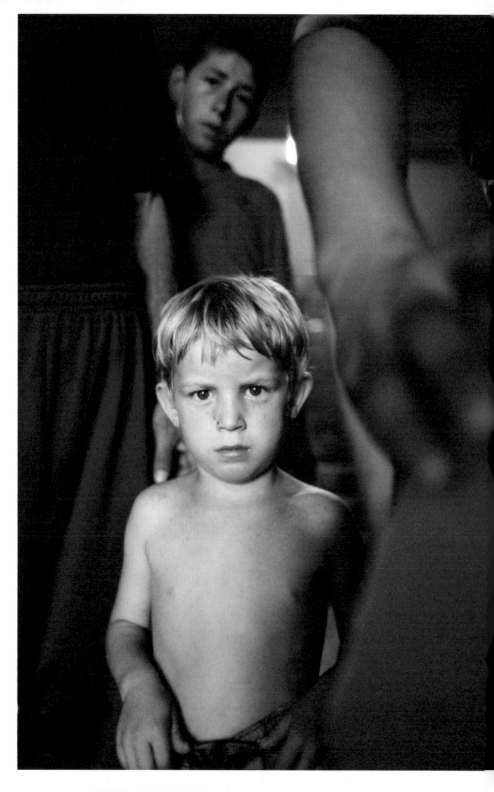

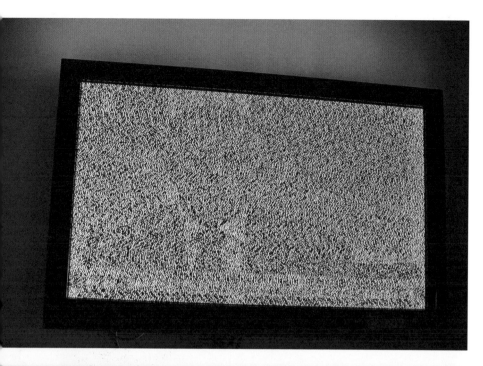

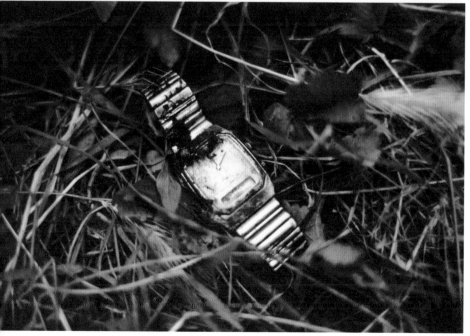

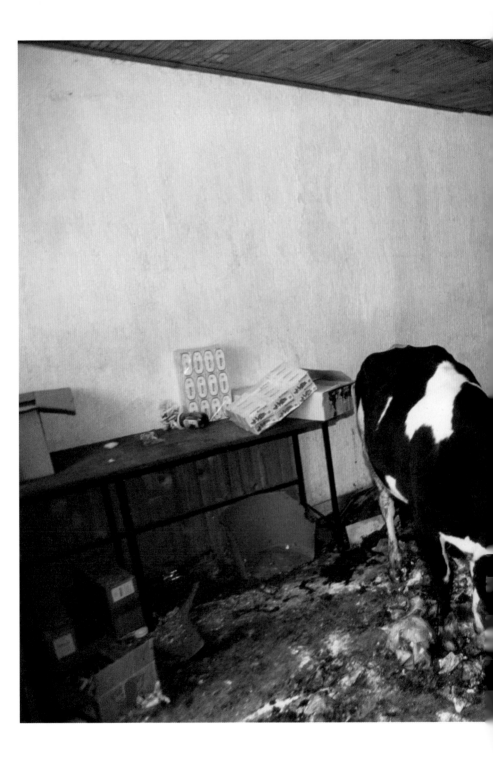

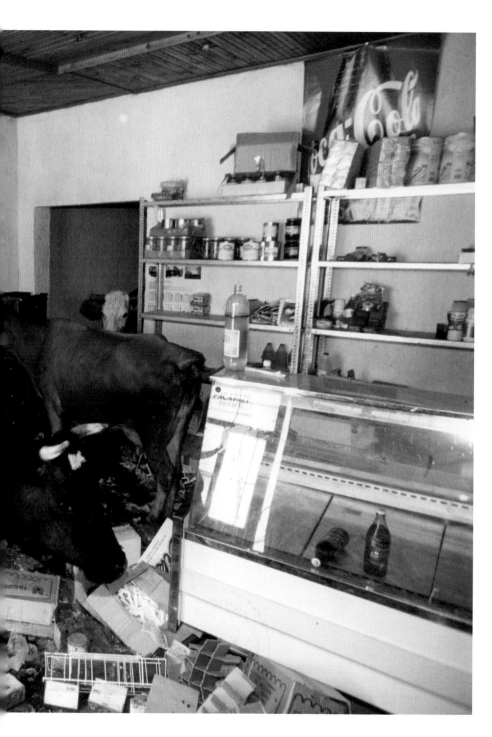

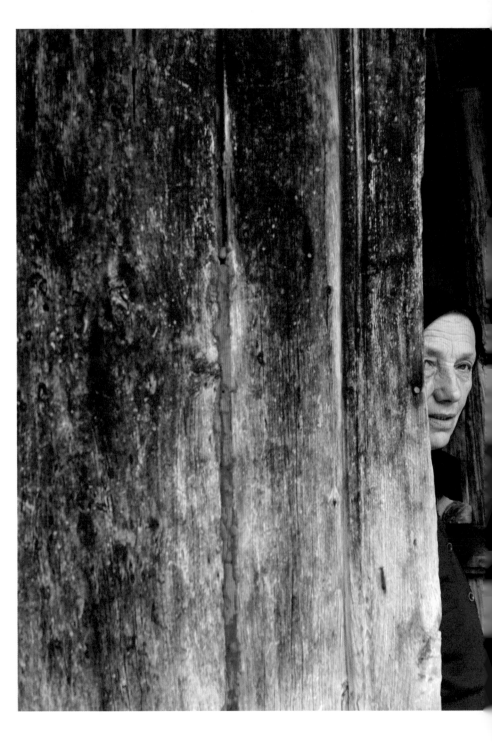

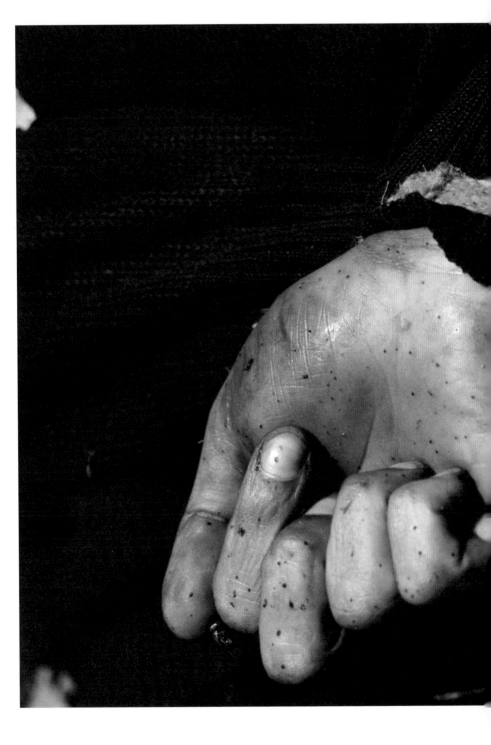

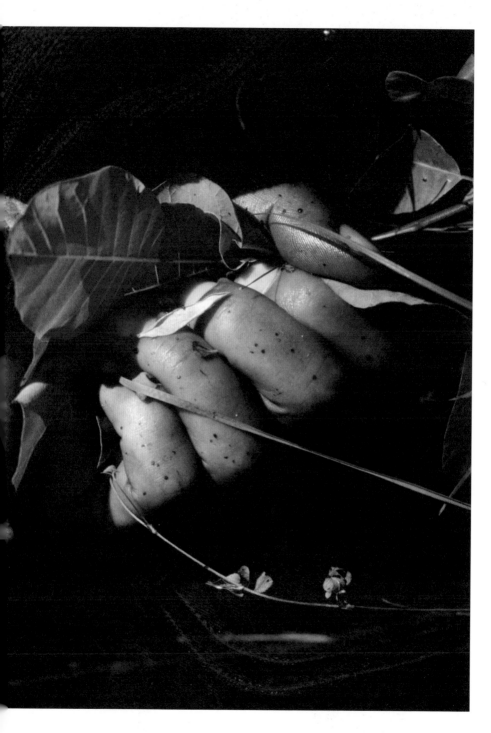

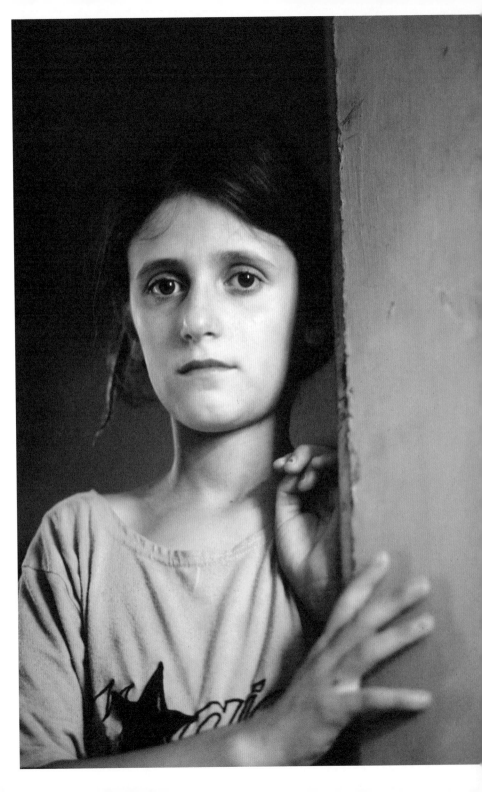

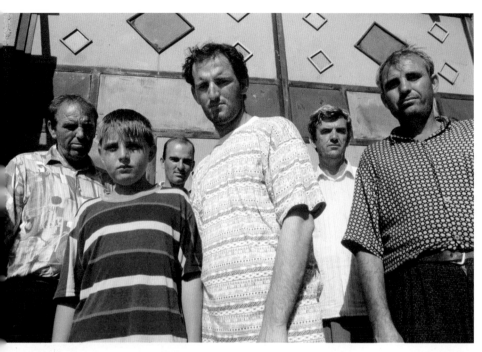

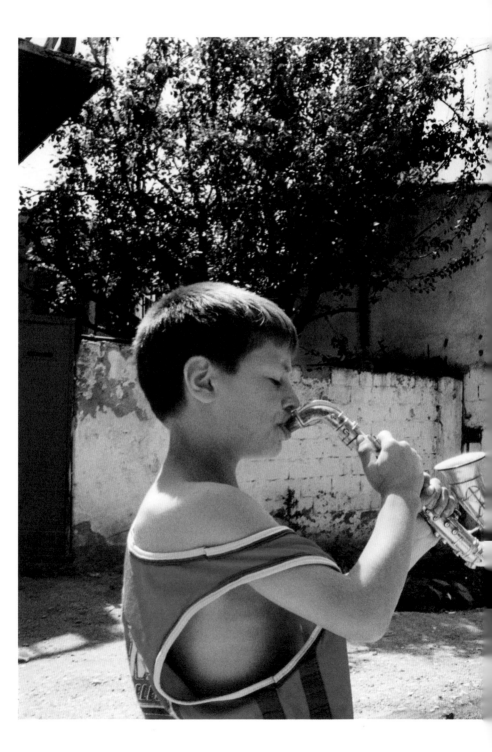

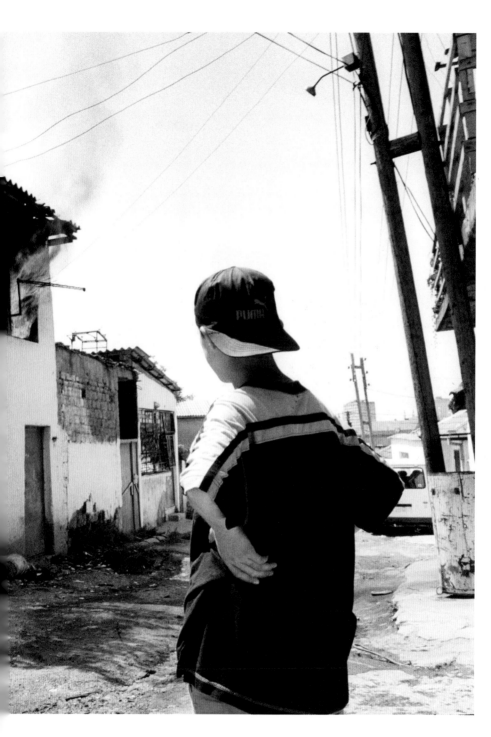

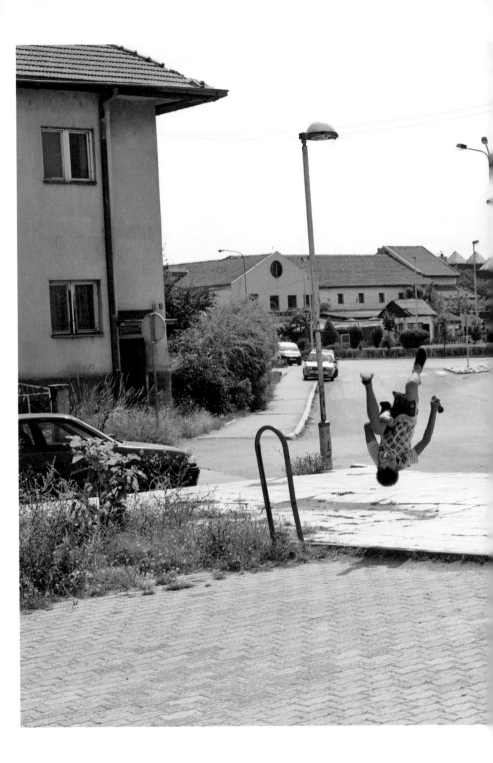

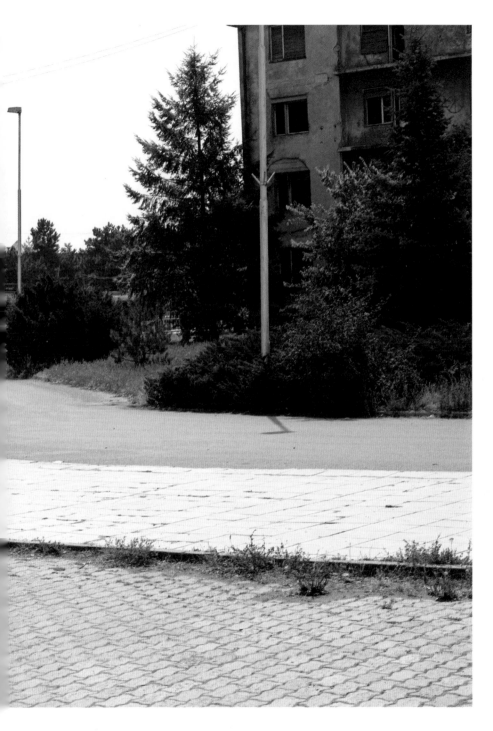

Afghanistan

The Orange Monkey

A restlessness took hold my brain,
and questions I could not hold back.
An orange monkey on a chain
on a bleak uneven track

told me that to understand
you must travel back in time.
I took a plane to a foreign land
and said, *I'll write down what I find.*

Beneath a mountain's jagged shelves
cloaked with snow and shadows sheer
plates tipped up upon themselves
the pain of fifty million years

and mules and goats were running wild.
A happy chaos carried on
and old men and young boys smiled,
and worked until the day was gone.

Packs of sandy-coloured dogs
walked streets that looked like building sites,
but piles of rocks and dust and smog
could not block out a different light.

When I returned I ran to meet
the monkey, but his face had changed.
He stood before me on two feet.
The track was now a motorway.

The Guest Room

One grey dove circles the ruins.
A jet heads to the base.

A boy sings to the bird.
He carries a blue gas canister.

Where shall I go?
I have no home.

I had a place
but guests came

and they remained.
Where shall I go?

He leads us through the village.
One cockerel. A pile of shoes

outside a curtained door.
We sit on orange cushions.

Children bring us tea and bread.
I wish we had brought gifts.

I hope we know when to leave.

Adhan

The valley's airbase lights came on.
The voices gathered and grew strong
sending out a single prayer.
I listened, but did not belong

so let my voice into the air
to see if it was welcome there.
The veiled mountain towered above.
A girl in red walked by and stared.

The darkening mountain did not move.
My voice trailed off and could not prove
itself within this foreign tune.
The night watched with a sickle moon.

The First Shot

One day
a shot rang through the mountains.
It rang and rang.

Children from the village
ran from their houses
to claim what was left.

Today
their eyes stare through us
to vast light.

They draw close
calling to each other
as they gather at the side of the road

carrying slings
to stone us.

The Hand

People pass the hand.
There are sounds of car horns and music.
People pass the hand that begs.

Three boys in hoods fold their arms
and swerve away from the hand,
the hand that begs in the rain.

A woman in blue will not look
at the hand that begs,
stretching out in the rain.

People come and go, looking at their phones.
Nobody takes the hand
stretching out, shining in the rain.

In the hollow of the hand
is a folded square
of paper,

but nobody looks twice at the white paper
that gleams in the hand that begs,
stretching out and shining in the rain.

The Beggars

She is squatting by the barricades
with a moon-shaped face
and does not smile or cry.
Gutters spill into the streets.

The air is thick grey fumes.
The sky is darkening.
Three lines of traffic edge past
the Ministry of Social Affairs.

An amputee and a pregnant dog
sit by young men with withered arms.
Some go from door to door
asking for bread.

The money-changers
sit by their locked glass cabinets.

The Boy

Boy speaks, *Follow me.*
Through the old city streets
you follow him past the tents
through the fog and excrement.

Smile at him. He smiles back
leads you past wooden shacks
and open gutters. Don't fall in.
Put your feet in his footprints.

Bullet holes in the walls
form a map of the world.
Giant door with a key.
Boy turns; *Follow me.*

Young boy in your face
every loss I can trace.
Follow you enter in.
Put my feet in your footprints.

An Initiation

In a cave in the side of a mountain
forty men are kneeling in a ring

chanting a song
of a single word

swaying forwards and back
sweating and wiping themselves with rags

calling out to god and god and god
driving their song into the mud

taking me with them, until at last
I stagger out blinking in the dawn

and see severed goat heads at the butcher's stall
still preaching the word

and reeling pigeons circling
wishes from god

and stray dogs, noses dimpled with pox
gatekeepers on the rooftops

and god in the small
dark bodies of children

damp in the mist
playing in the cemetery

barefoot
in December

Charikar

They fight with kites. They fight with eggs.
They fight with goats without a head.
There must be something in the air.
There is fighting everywhere.

A pack of dogs are in the lane.
A group of boys are baiting them.
It's not a game. They're out to win.
They have to get some practice in.

An old man stands beside a flag.
He holds a crook and a carrier bag
and curses underneath his breath
as fighter jets pass overhead.

They fight with rams. They fight with larks.
They fight with knucklebones and calves.
There must be something in the air.
There is fighting everywhere.

At the Bird Market

Seven children
with rings of fungus
on their faces
follow us down the alley
just wide enough
for a wheelbarrow.

A man in eyeliner
beckons us over:
on his right hand
a velvet glove,
inside it a tiny
fighting lark.

On red baler twine
hundreds of dead
sparrows hang
by their feet
spinning slowly
their mouths open.

The Glass

A boy stares through the glass.
He's saying, Dollar, dollar.
Three lines of traffic pass.

We're trapped inside our car.
His voice says, Dollar, dollar.
His face against the glass.

I turn to you to ask
for something we can offer.
Three lines of traffic pass.

We pull away so fast
all my words get swallowed.
In the rear-view glass

a face pock-marked and hollow
that should be growing smaller
is saying, Dollar, dollar.

It stares back from the glass;
I can't look through or past.

Poem

And sounds of weeping came instead of music

And I walked out trembling and pushed my face
 into the soil

And sounds of weeping came instead of words or speeches

And dark evenings arrived at dawn and wailing
 rose from the village.

Dead Tanks

beside the Panjshir River
a blackened armour
let fall at high water
thirty years before.
Silent except for a numbing wind.
Downstream kids shoot slings
between sheets of metal.

Trees burnt to their upper limbs
somehow continue to grow.
Pale grass through
the collapsed hulls.
They rust and wait
until the waters rise again.

Talking to Dog

The king of his domain.
A watchful silhouette
beside the palace walls.
A phantom at sunset.

The dog I climbed to meet
was one of many strays
you see walking the streets.
This is what Dog says:

I saw this city built
two thousand years ago.
I've seen the foreigners come.
I've seen the foreigners go.

I saw the troops arrive
and start a tug of war.
I saw a border drawn
which killed ten thousand more.

I saw this palace built.
I counted every stone.
And I will be here still
long after you have gone.

Begging Bowl

A brass dog
with two heads
shows his teeth
and wears shoes
His belly
low hung
smooth and hollow
fits the palm
His four eyes
black holes

At the Airbase

The convoys are rolling in.
Men and women wearing shades
point their guns at the plains.

Sand rains down on children
dressed in rags
at the side of the road.

They dare each other
to step closer.
Dollar Mister, Dollar Mister.

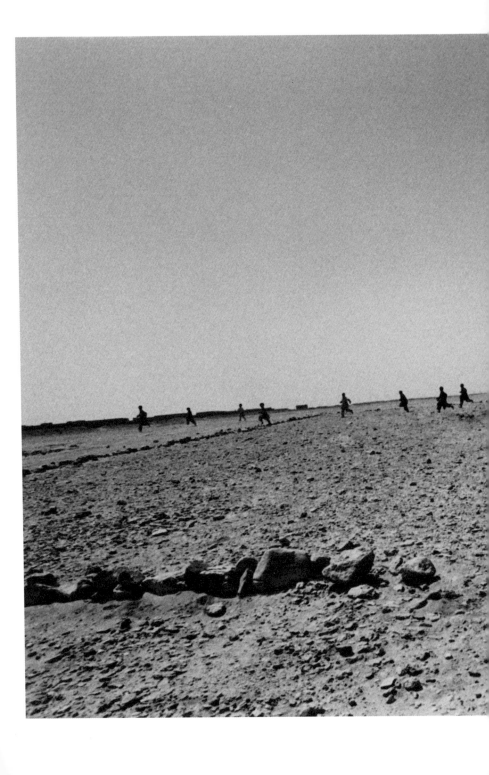

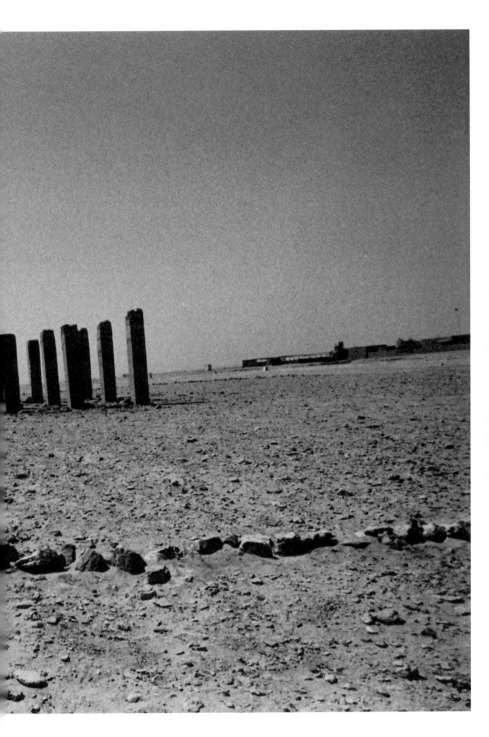

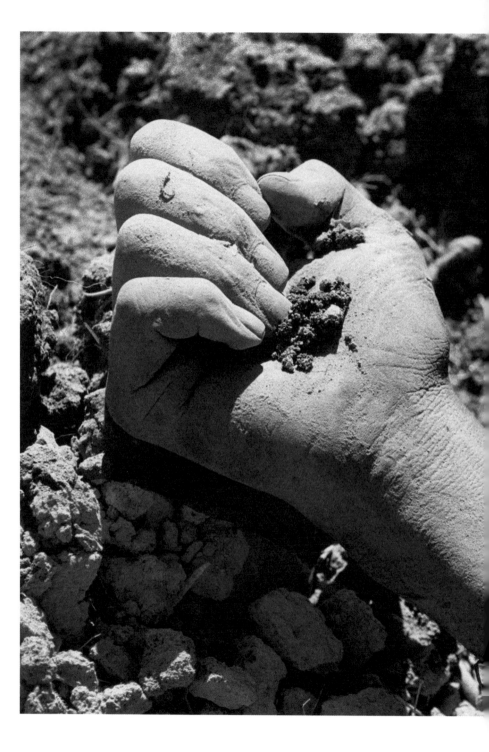

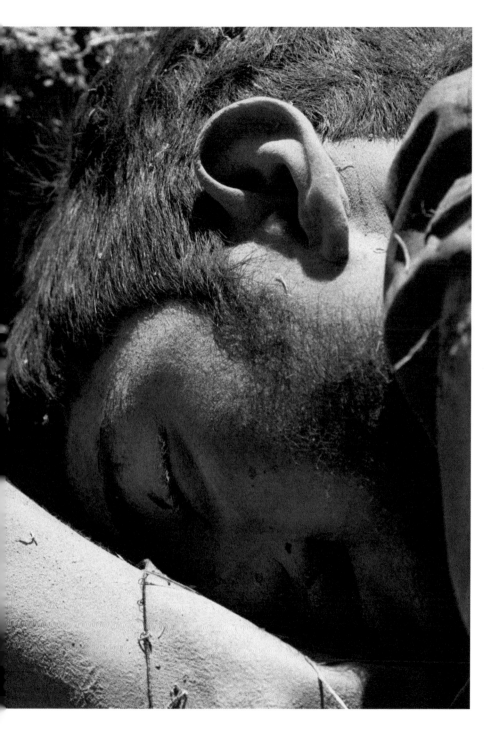

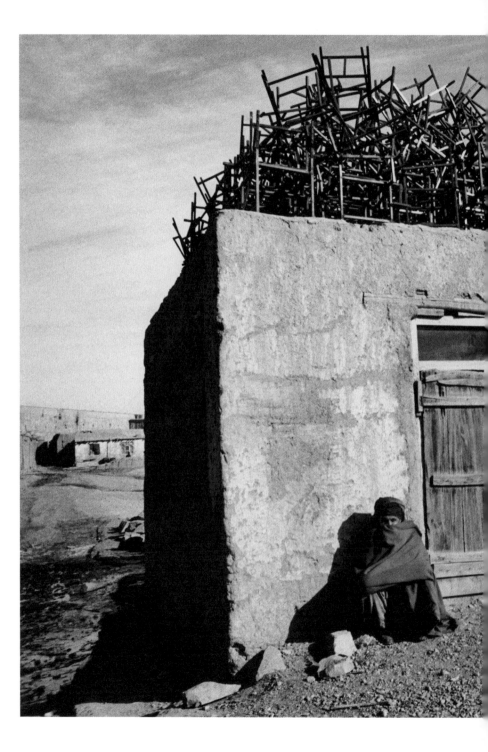

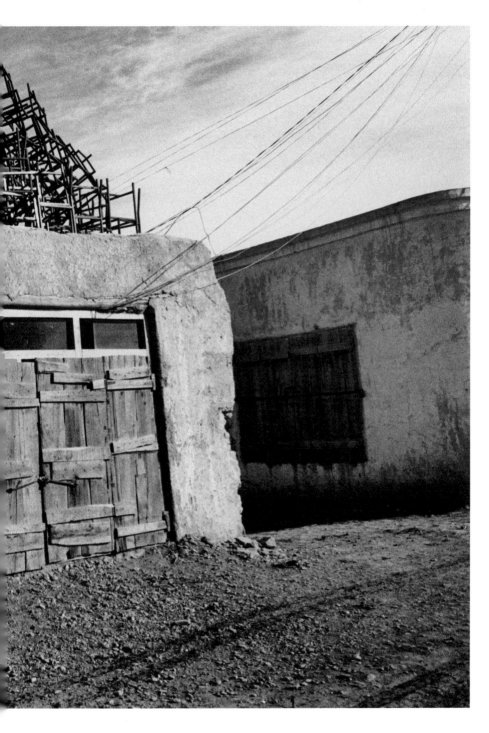

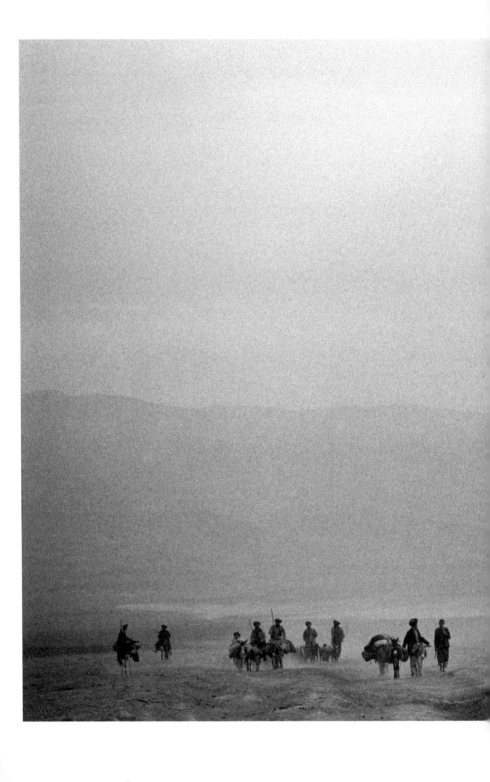

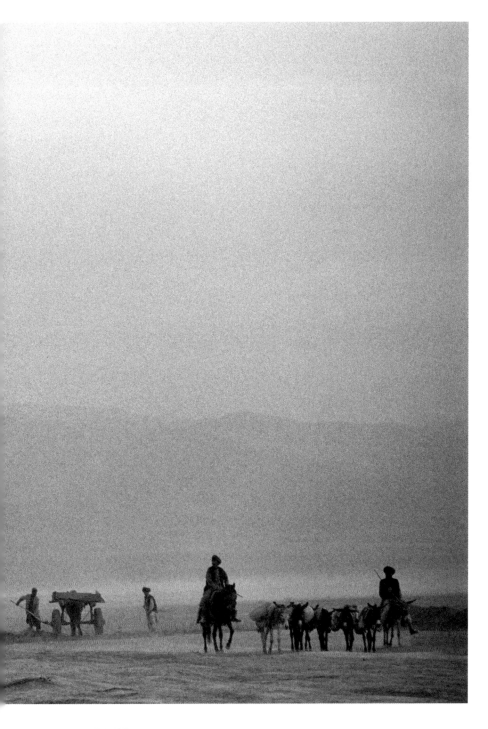

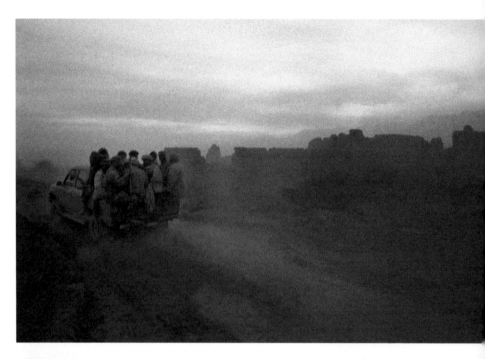

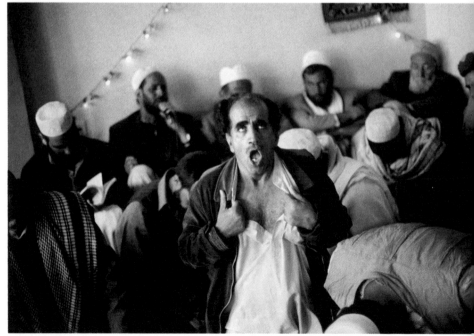

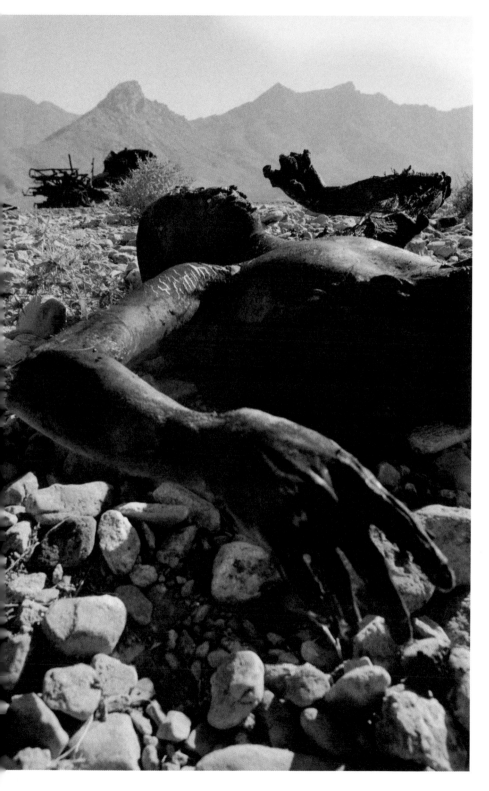

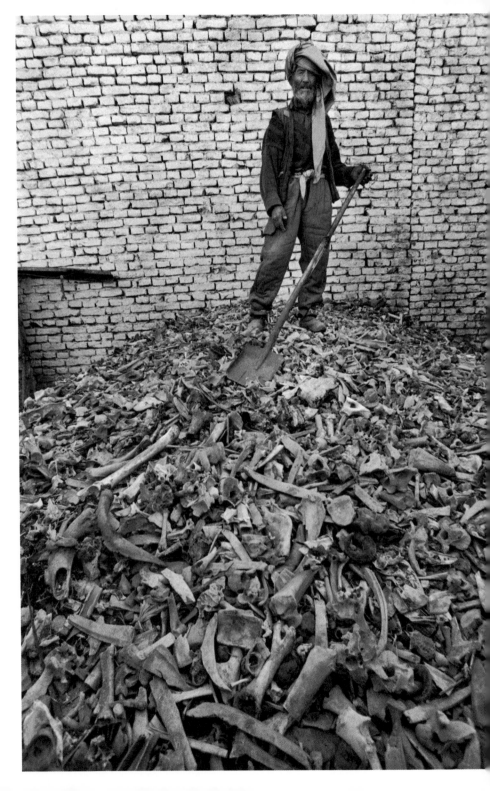

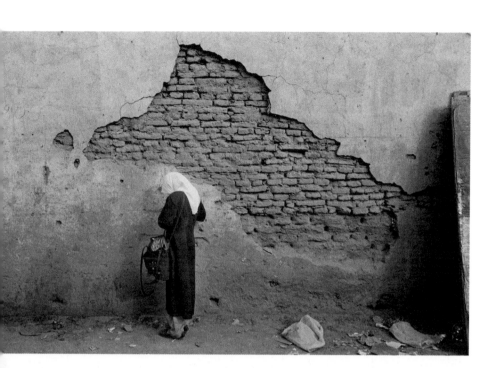

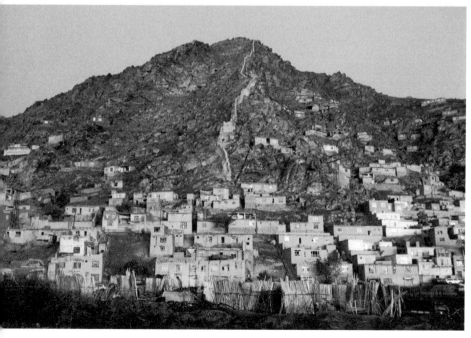

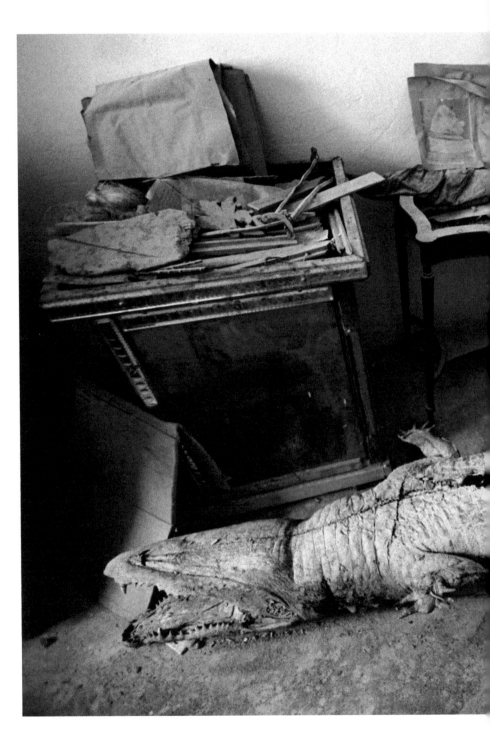

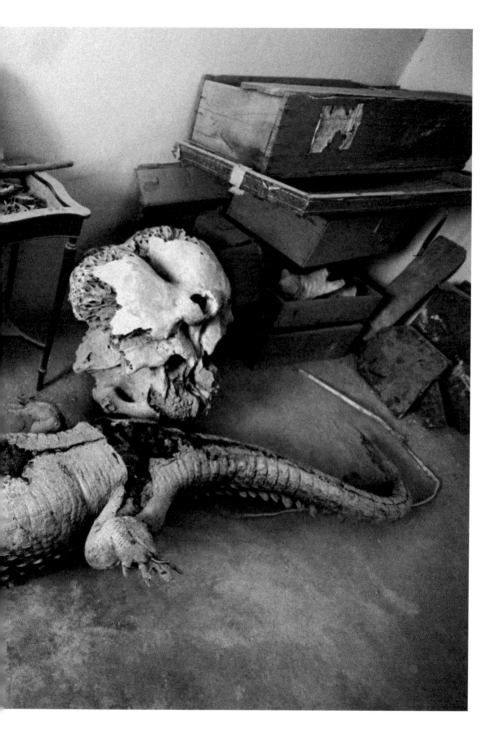

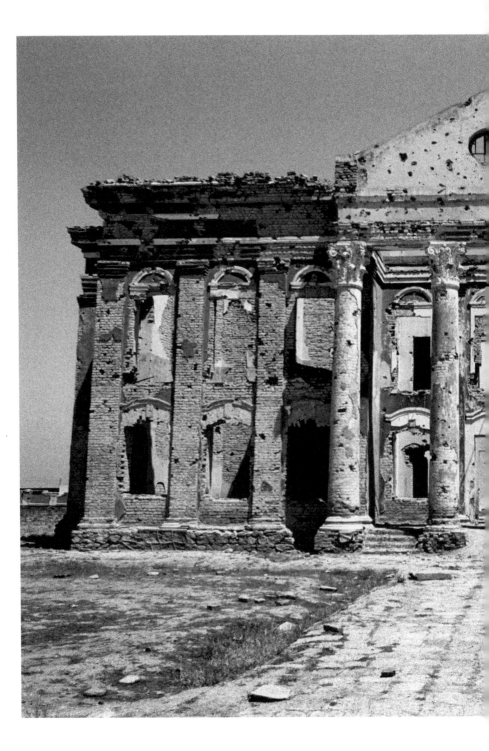

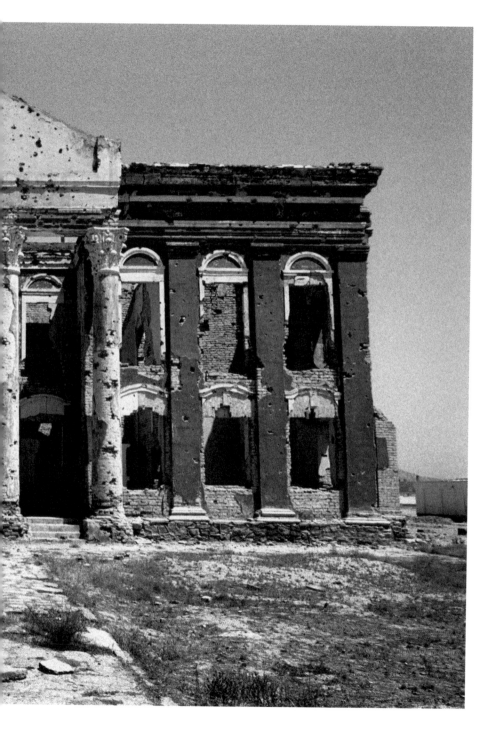

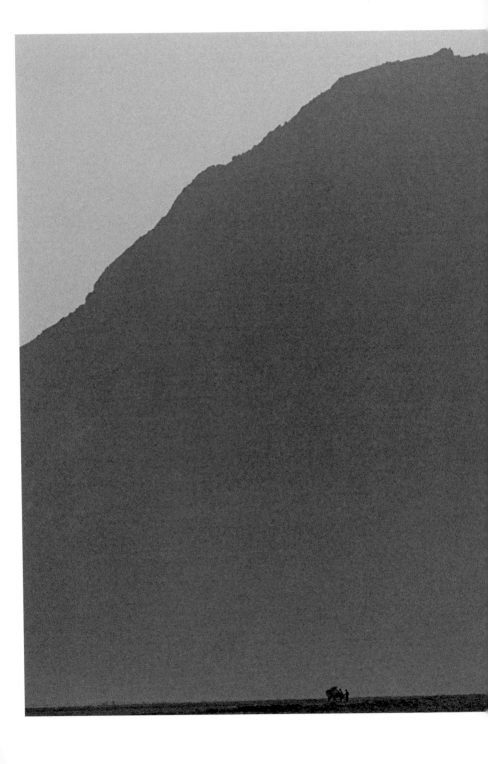

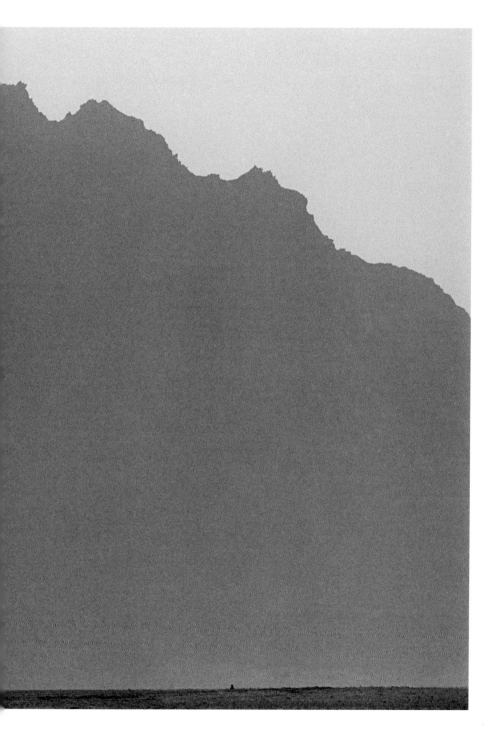

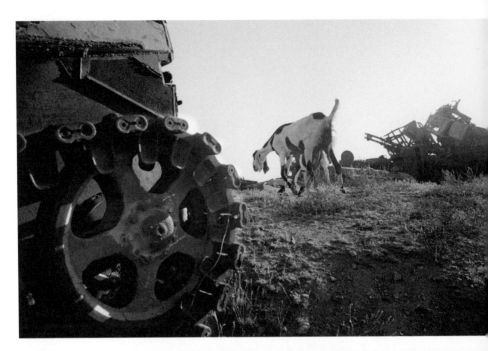
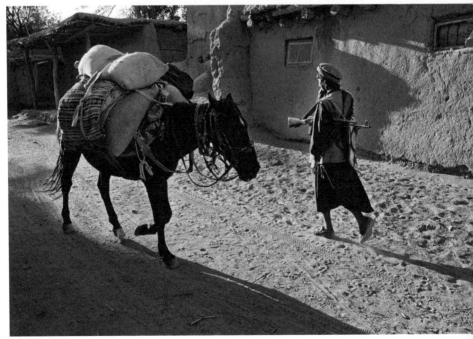

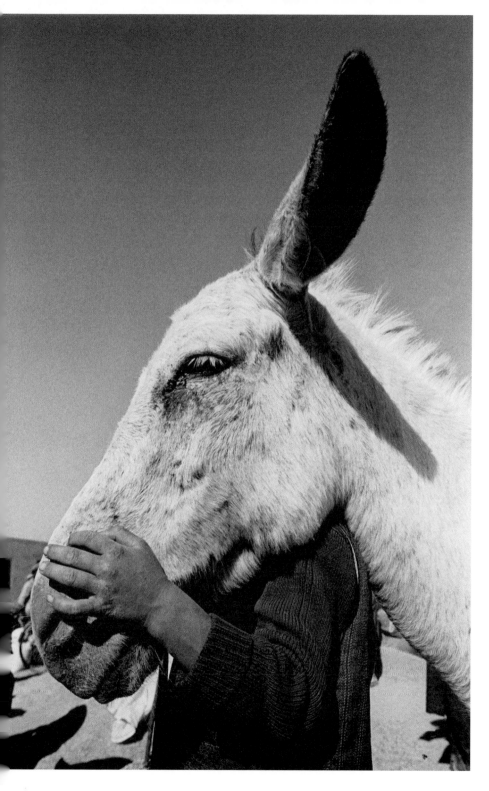

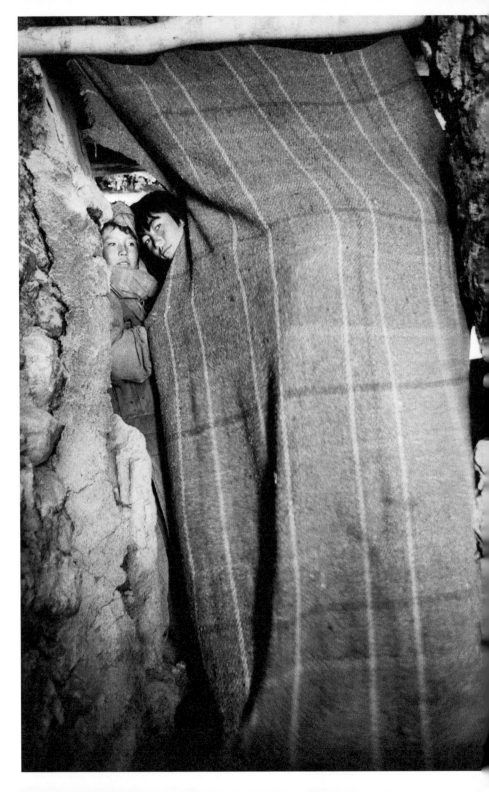

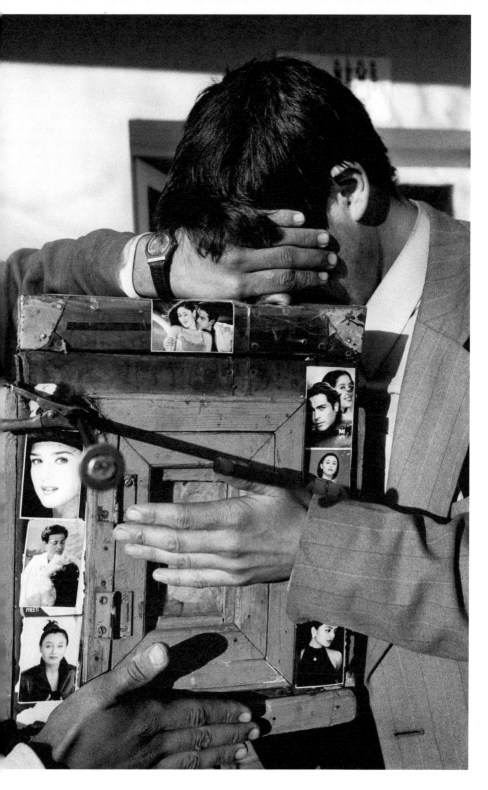

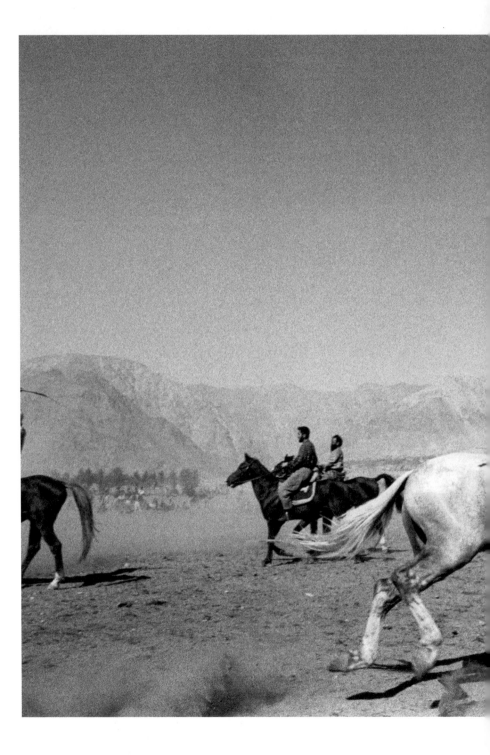

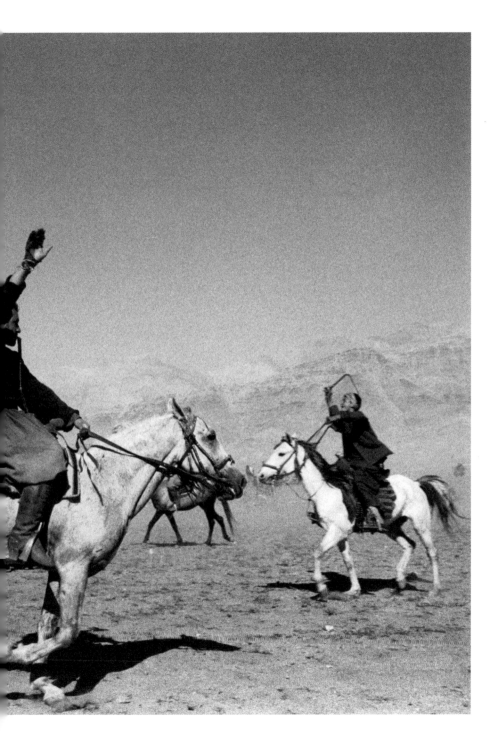

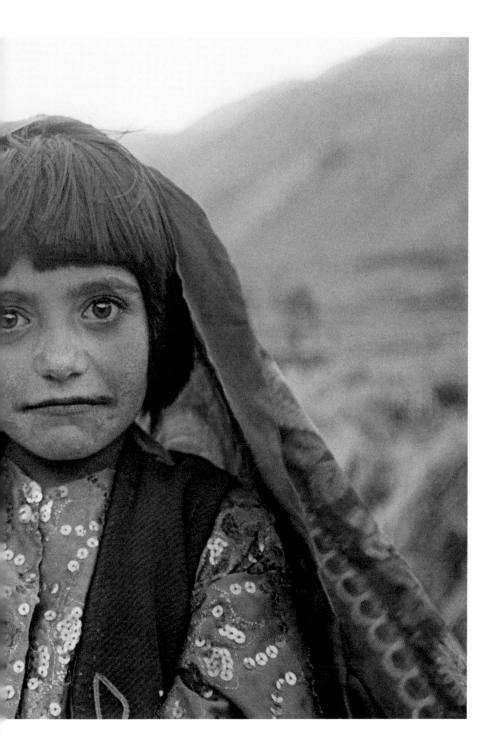

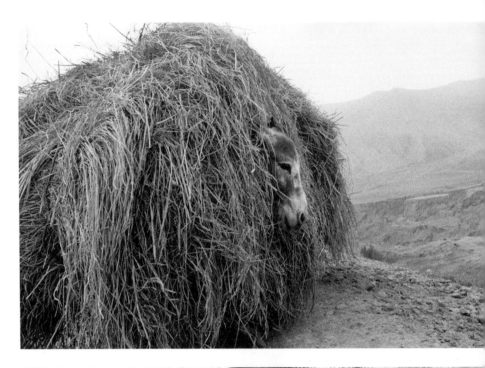

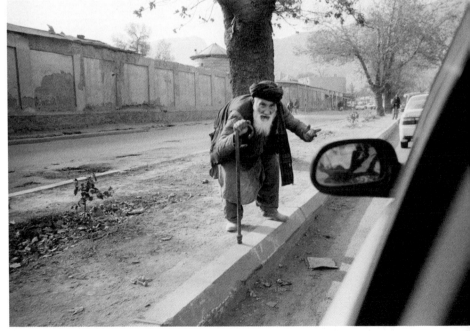

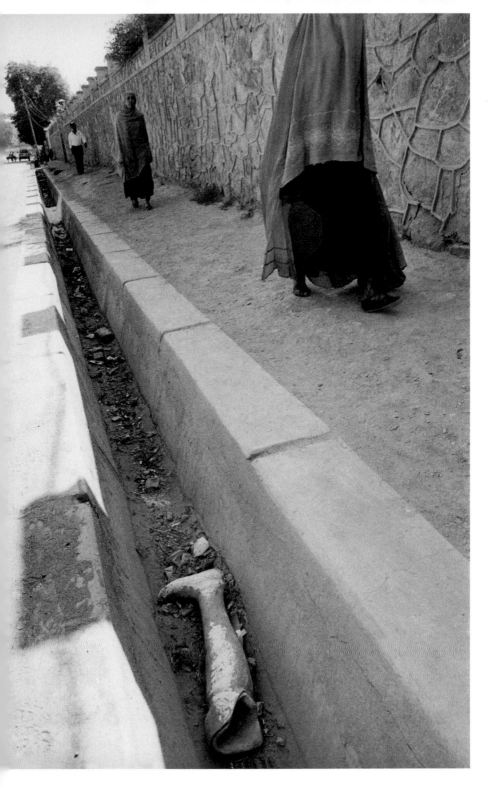

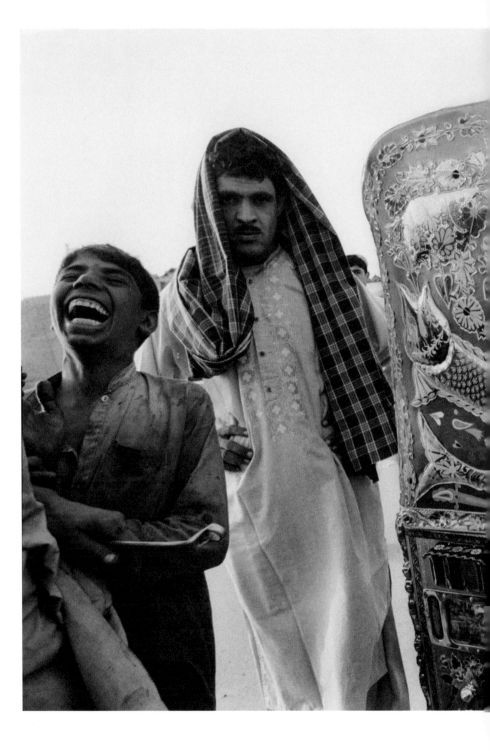

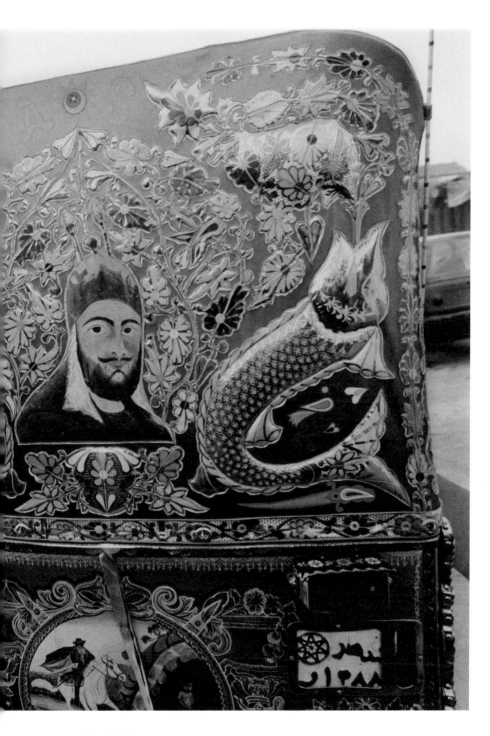

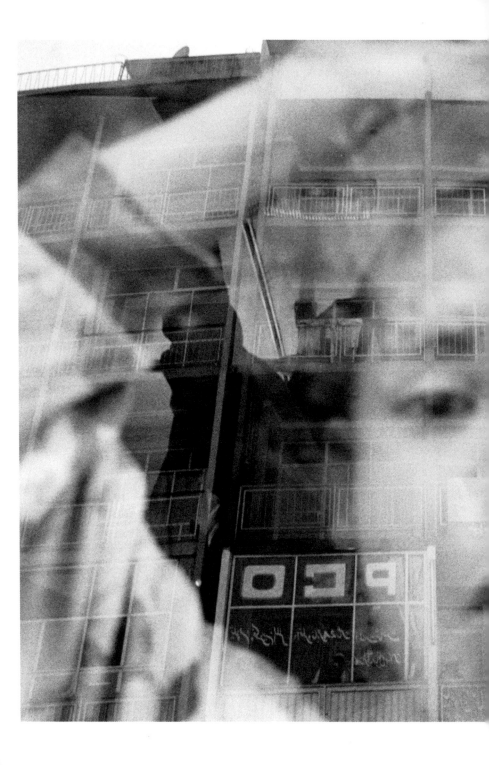

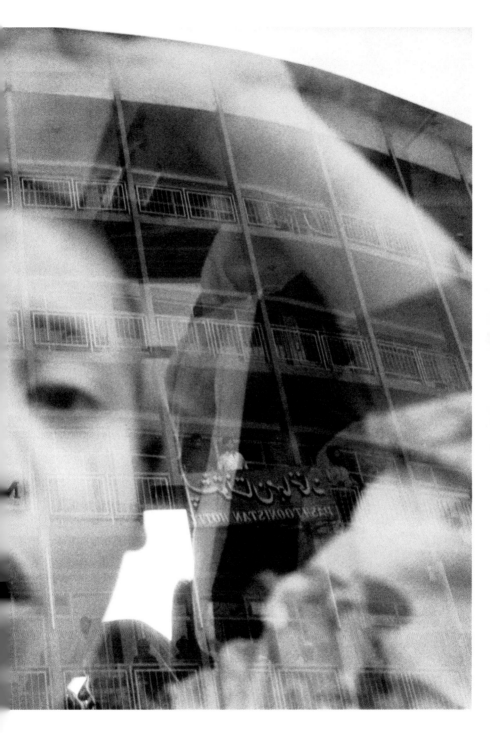

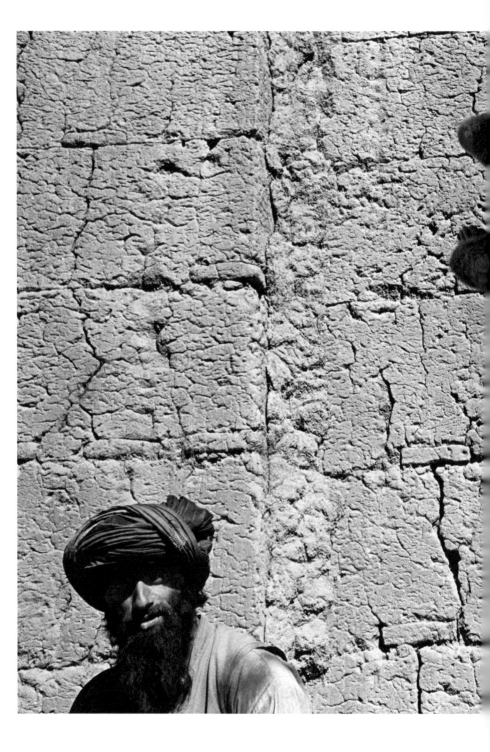

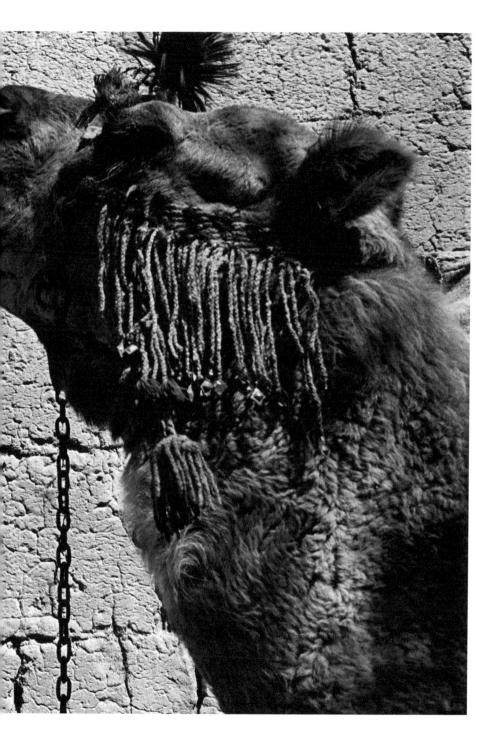

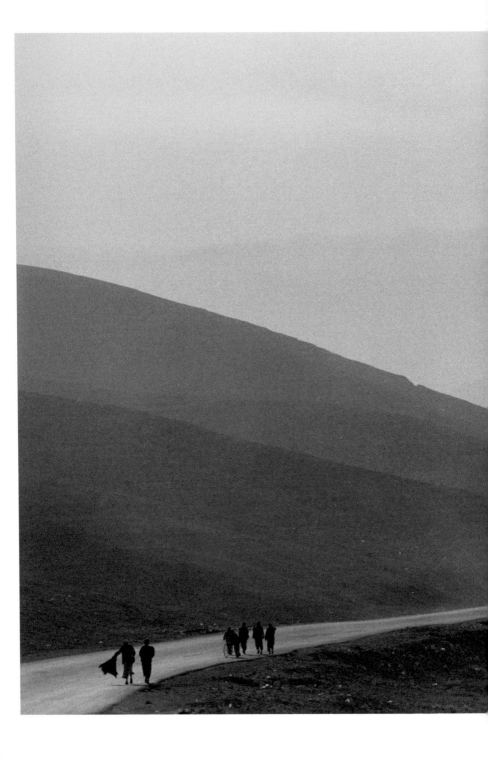

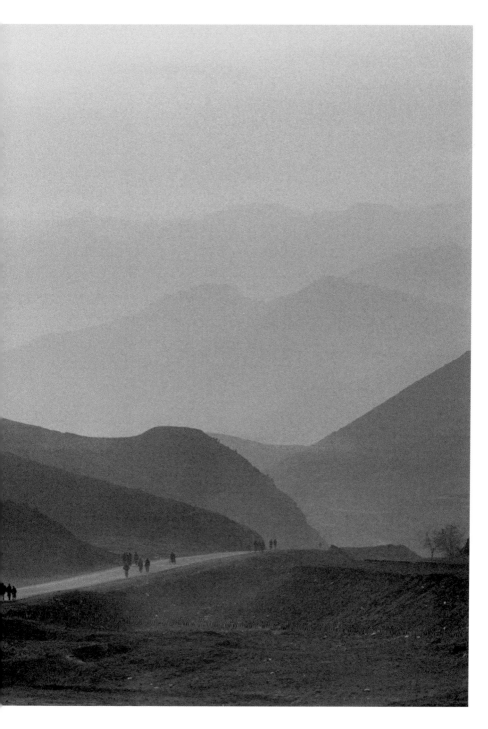

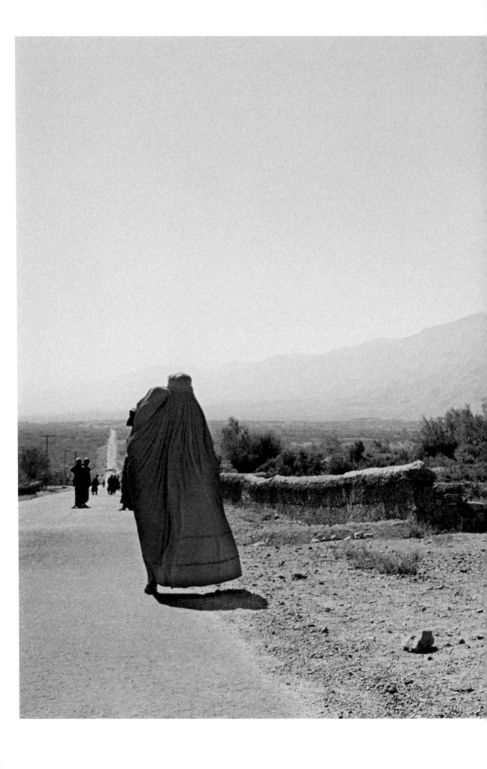

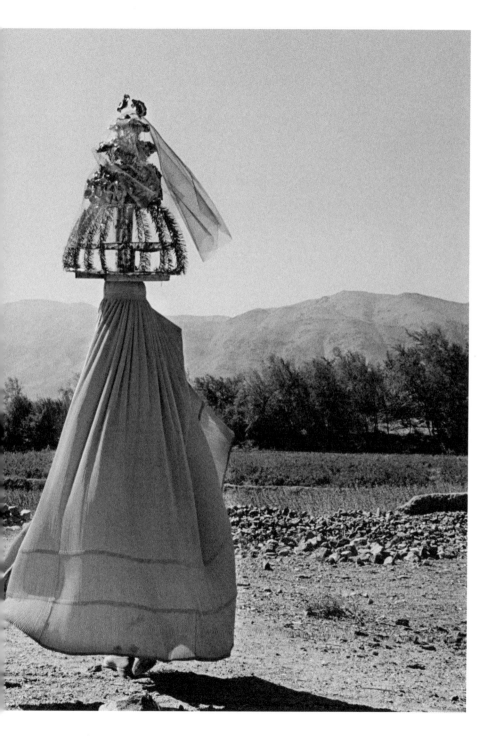

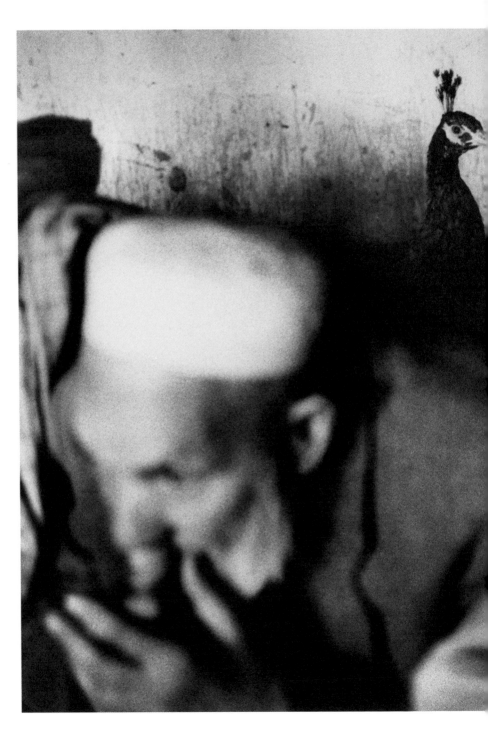

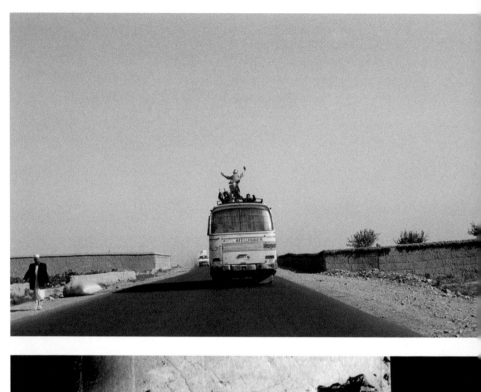

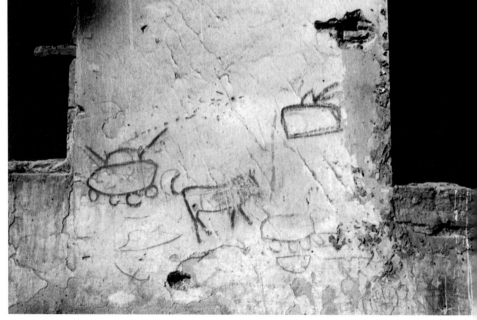

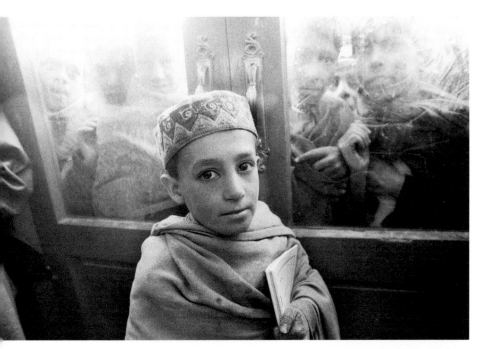

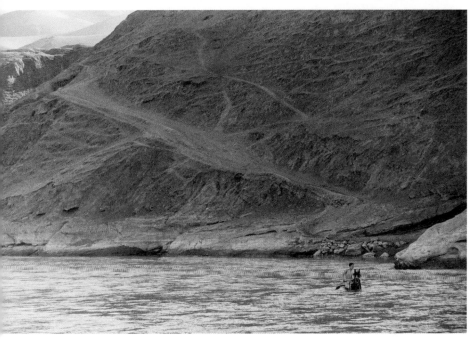

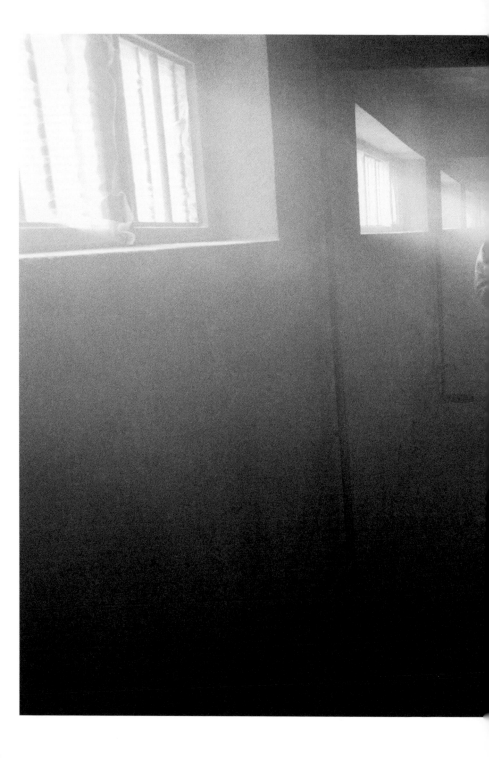

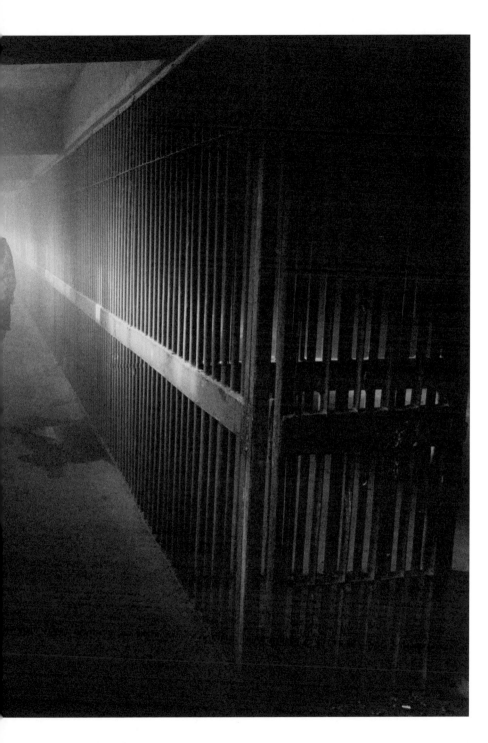

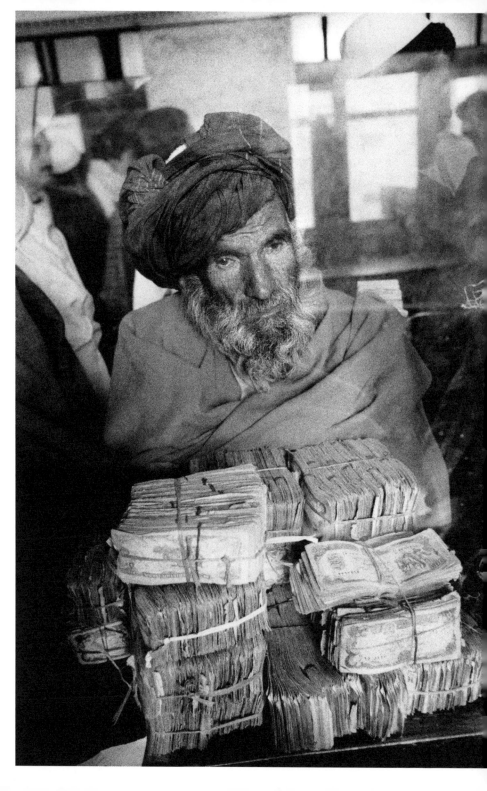

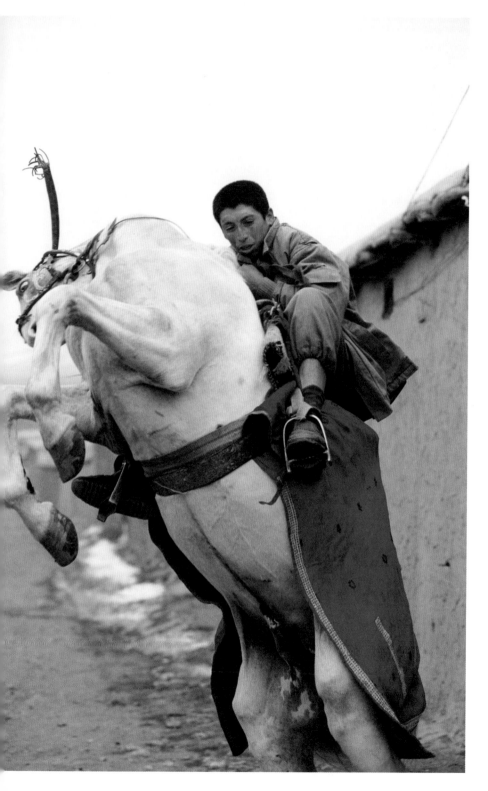

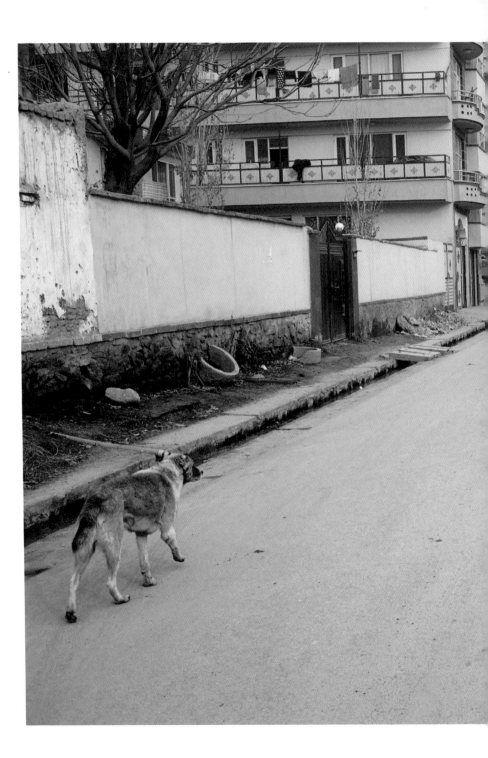

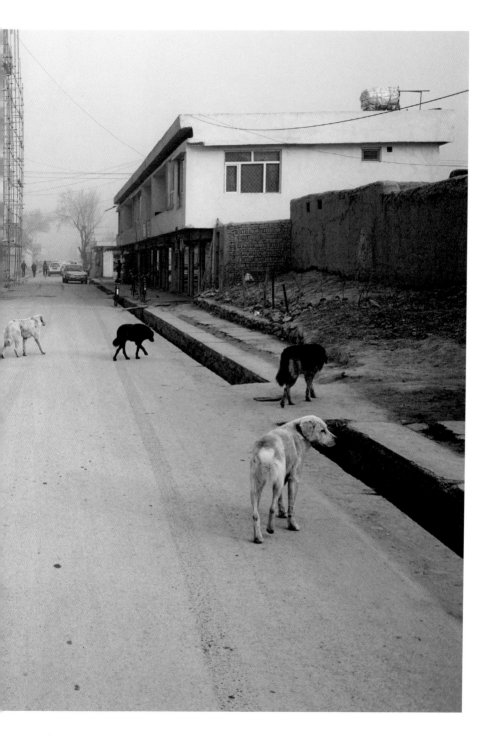

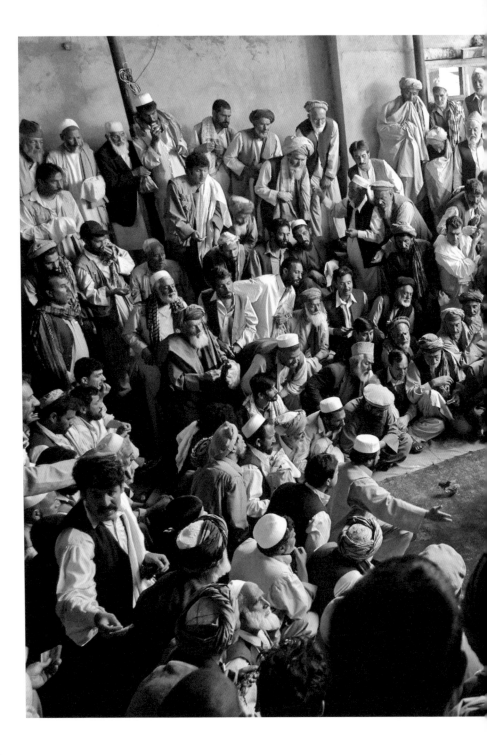

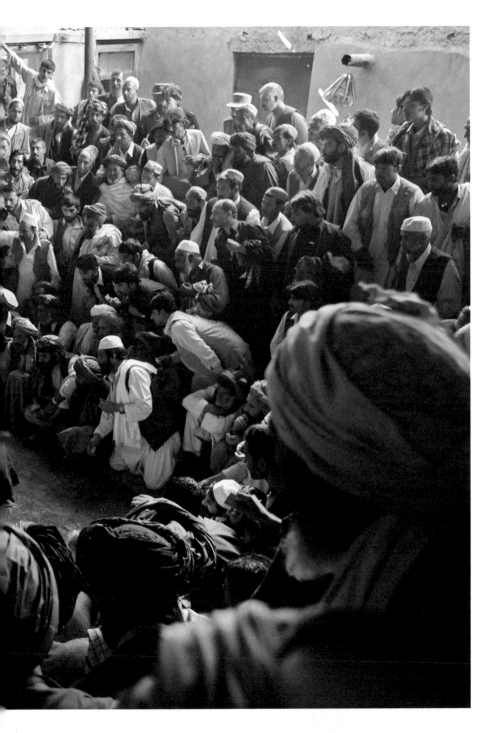

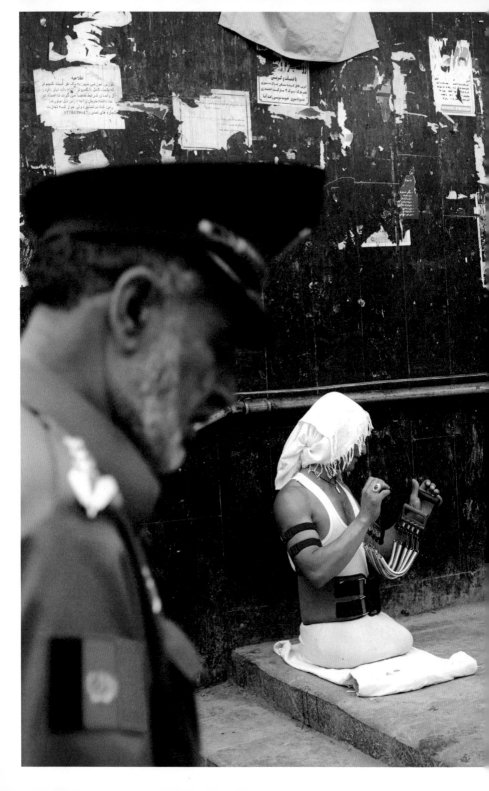

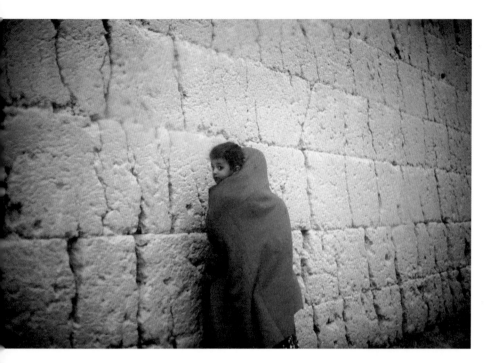

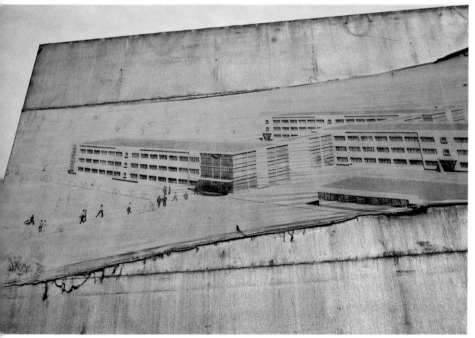

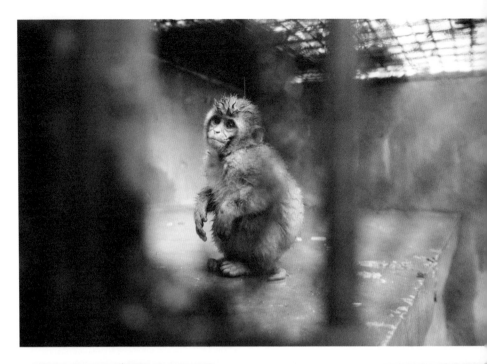
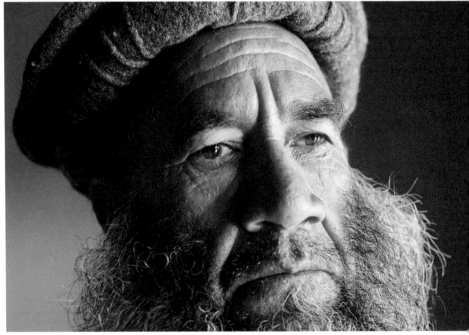

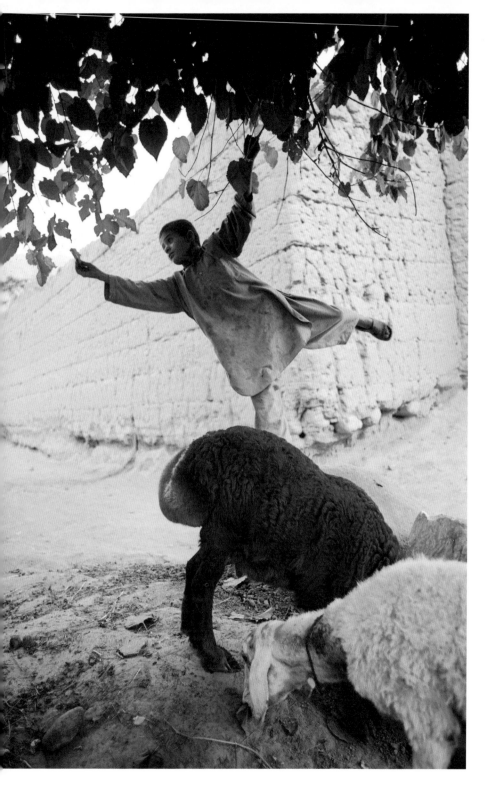

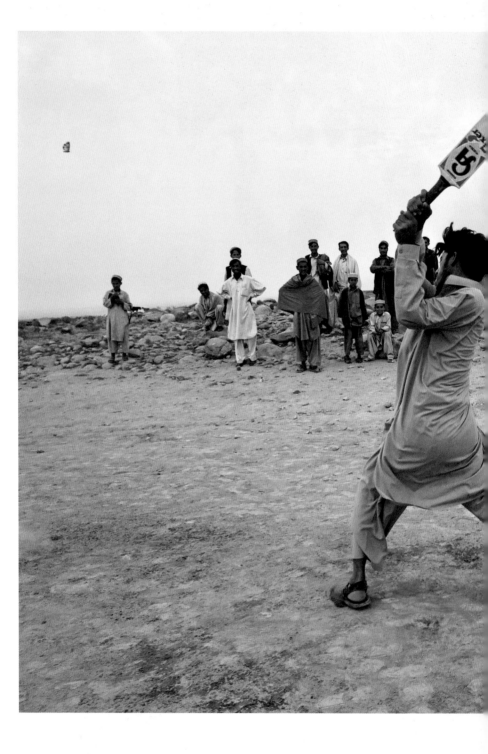

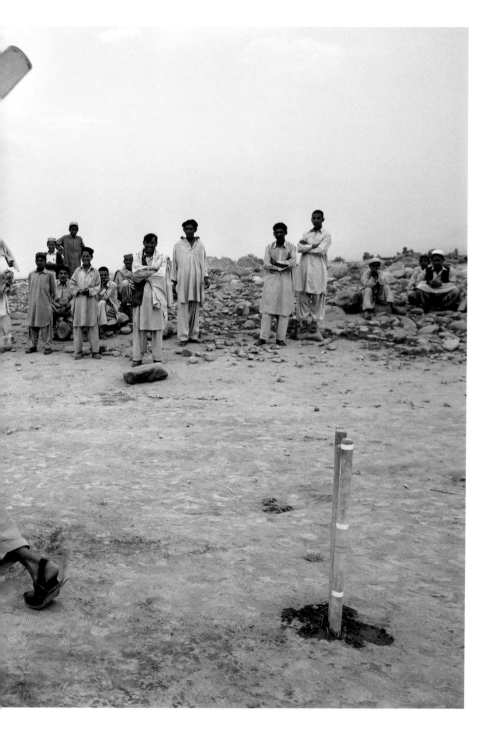

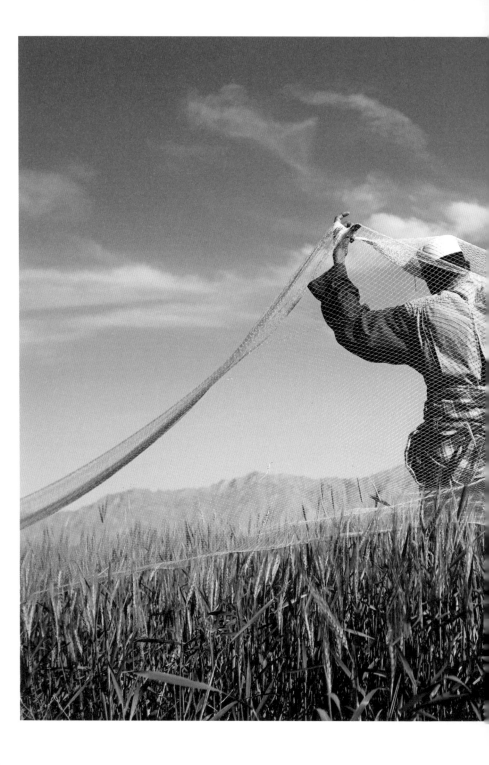

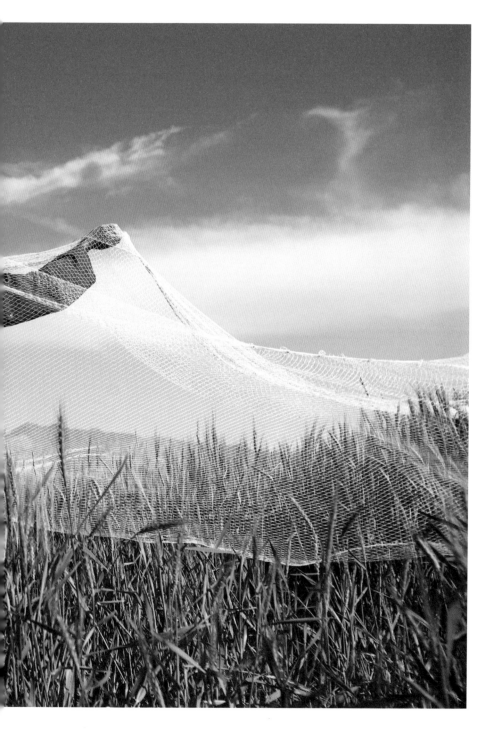

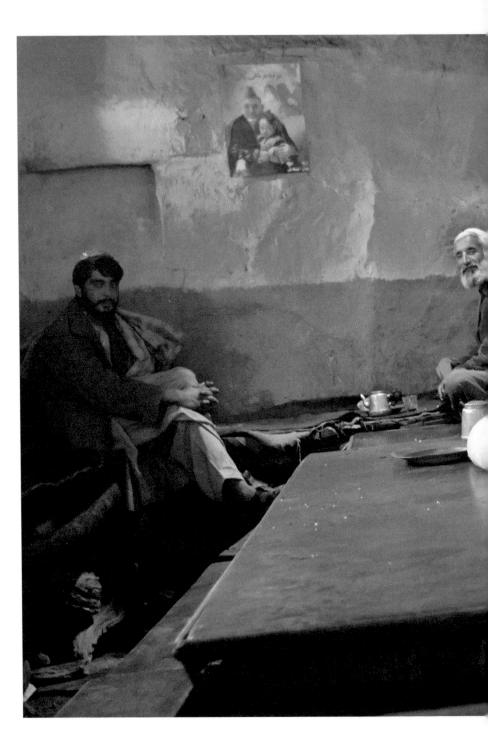

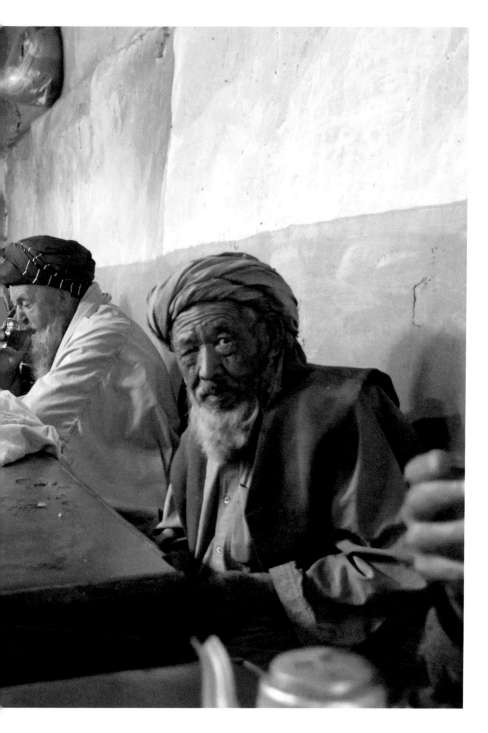

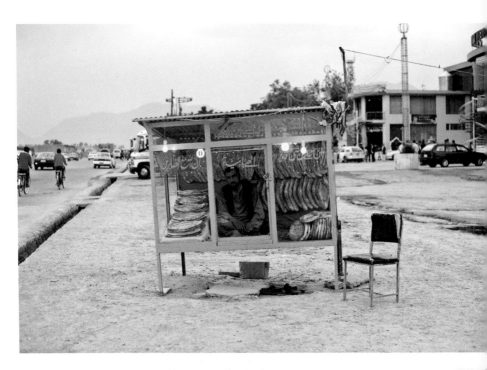

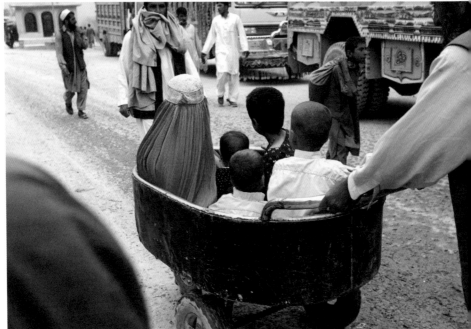

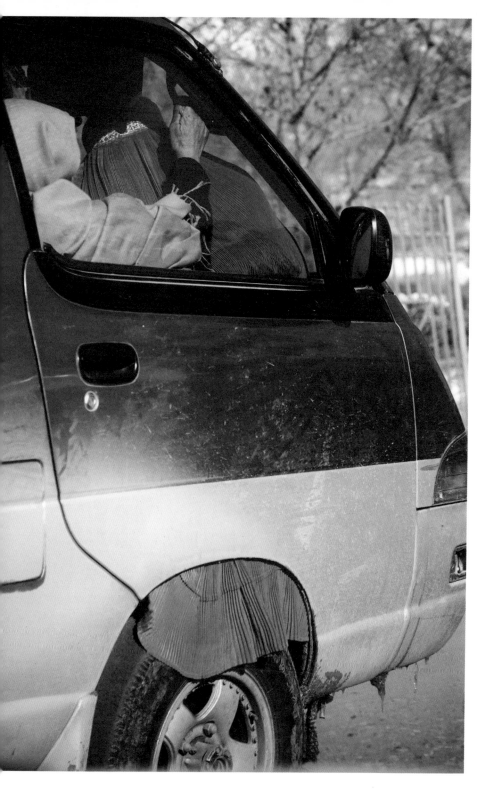

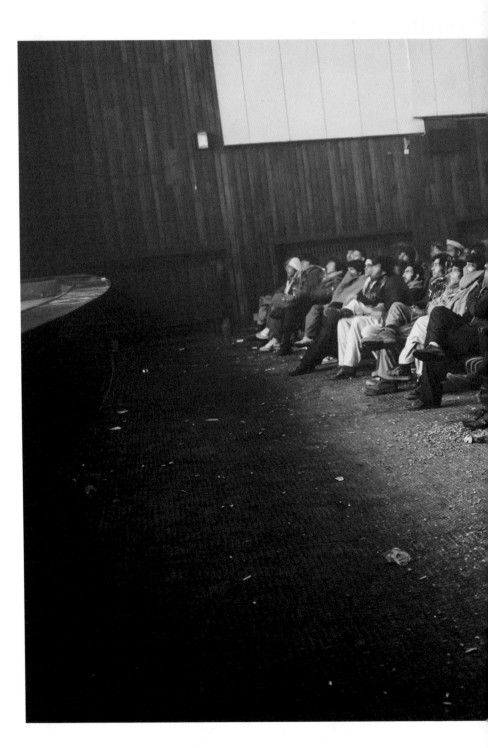

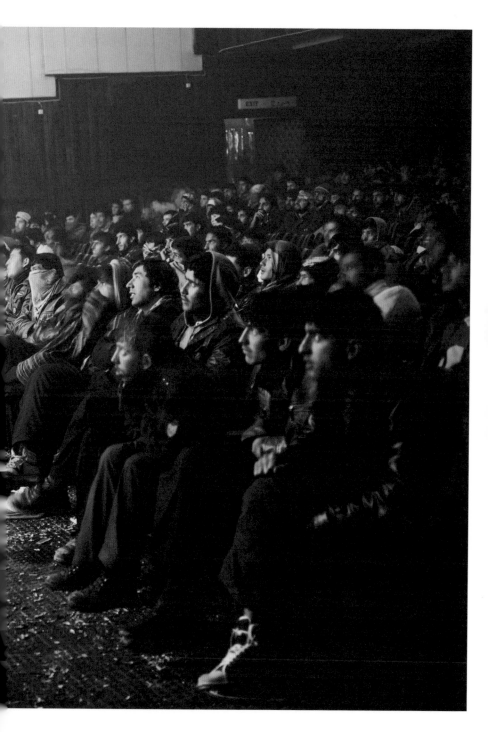

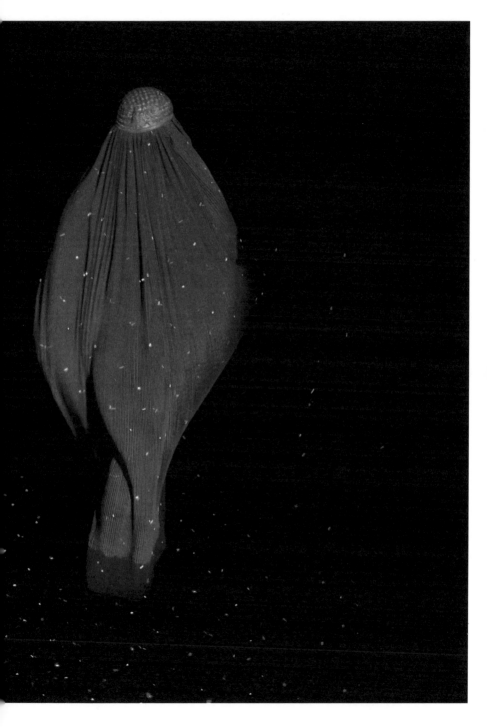

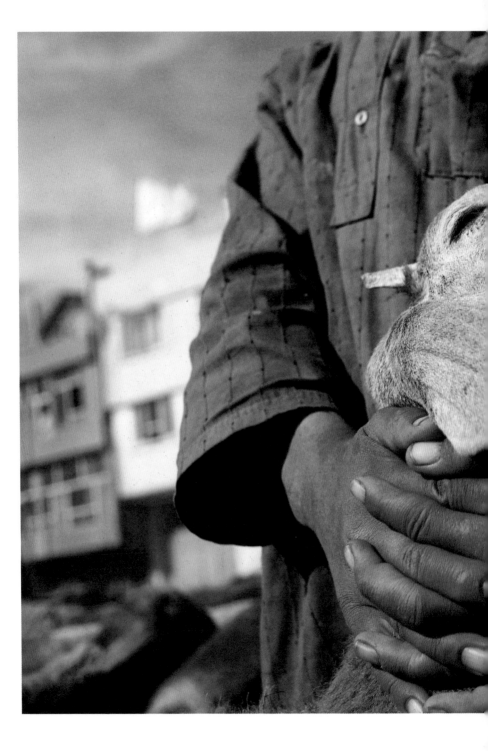

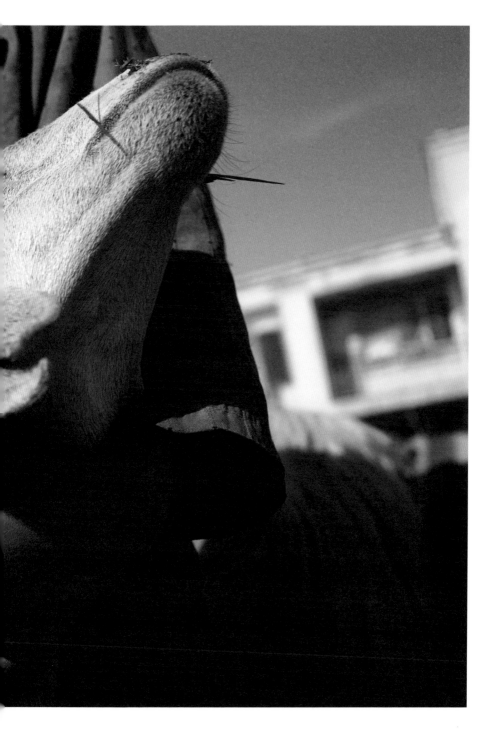

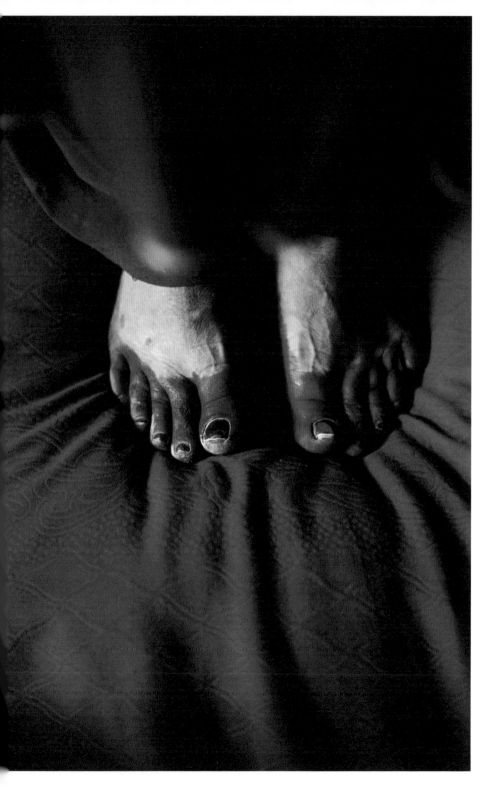

Washington DC

'African Voices'
(National Museum of Natural History)

Between *The Ice Age*
and *The Ocean*

one small room display.
It's quiet in here.

There is a coffin from Ghana
in the shape of a KLM jet

and a gold-weighing kit
of tiny brass objects:

A European Caravan
A Chief's Chair

A fourteen-year-old boy from Rwanda
has made a Conestoga wagon

out of wire, cardboard and wood.
At the front of the wagon

is an American cowboy
with a black moustache and stubble

a red, white and blue tin hat.
He whips a mule.

An identical cowboy
rides at the back of the wagon

holding a gun made out of tape and wire
as big as the man.

Sight-Seeing, South of the River

'Here's the Hope Six Demolition Project and here's Benning Road, the well-known "pathway of death". Here's the I-HOP – the one sit-down restaurant in Ward Seven. Nice. Okay, this is drug town. Just zombies. Lotsa wig shops, lotsa baby-mamas as they call 'em. The Mayor planted trees. See how the trees make it better... So here we are on one more pathway of death and destruction... South Capitol – you can take this baby all the way up to the dome. The school looks like a shit-hole, right? Would you want to go to school there? Does that look like a nice place? Here's the old mental institution that's gonna be the Homeland Security base. Here's the M.L.K. Deli, here's God's Deliverance Centre. Okay, this is the border of Seven and Eight. Here's the Community of Hope. They're gonna put a Walmart here.'

A Guy Who Knows What the Fuck's Going On

I look at the news an' I see it right
– they're coming – see this is the last frontier
they locked the borders a long time ago
it was all a twenty-year plan
that's what it's all about, an' they're coming
that's what's really going on

The neighbourhood kids
roll dice for dollars
sitting on the stoop
calling out to *Money!*
Money! Money! –
their dog.

It was all staged – everything is staged
that's how it is here in America
– it's just so simple man –
people are jus' paid an' bought an' shit
an' that's the whole fucking bottom line
I saw what was happening from day one

To the Oldest Homo Sapiens

A jaw. A leg bone.
A reconstructed skull.
Your teeth are just stumps.

You have not eaten well.
Ityopya, aitho ops, 'burnt face' –
what sent you from your cave?

Your migratory path looks like a tattoo
I saw on a black kid's forehead.
They die young around here

with hungry bellies and a taste for vodka.
They wear T-shirts of their friends' faces.
Last year one got killed just for his shoes.

What god sent you? Tell me.
Is there a god of none and plenty?
The electric light hums.

Voices behind me
whisper in a language
I don't understand.

On the Corner of 1st and D

One old man is saying three words,
reaching out like he wants to gather
good. His white stick taps the ground
forever. Above the rooftops

a solitary dove sings three notes over and over:
spare some change, spare some change
over the roof of the shopping mall,
spare some change

over the roof of the government building,
over the roof of the Supreme Court.
The earth yawns and turns its face a millimetre.

The moon holds up an empty plate
above the corner of 1st and D,
above the gathering of men and women.

3 a.m. Washington DC

You walk to the bridge over the 395 freeway
until you find them
standing near the soup kitchen in the May heat
and stare, because tonight you can
and you ask them *Where do you come from?*
and *Why do you wait here by the screaming traffic?*
as the circle of men and women
all of them with dark skin
let you in to stand with them
and you smell fire and peat
as the mock-Greek architecture
sinks back into marshland
and the cicadas sing
as cedars replace the mall
and Spanish moss the sidewalk
and all that's left of the Capitol
is a quartzite rock
three hundred million years old.

Medicinals

We were always here
say the little bluestem grasses
whose ashes were used to treat our sores.

We were always here
says the broomsedge with its slender stalk
once used to soothe poison rash.

We were always here
say the sassafras
the sumac and witch hazel.

I was always here
says the shallow marshland
from beneath the walkways of the National Mall.

I am always here
sings the woman in the wheelchair
with her plastic bags swinging

and her Redskins cap on backwards
as she takes another draught from a bottle
inside a brown paper wrapper.

Throwing Nothing

At the refreshments stand
near the Vietnam memorial
a boy throws out his hands
as if to feed the starlings.
But he's throwing nothing;
it's just to watch them jump.
Three long notes sound on a bugle
and a man in overalls
arrives to empty the trash.
He hauls it to a metal hatch
which opens to the underworld.
An alarm bell yammers.
The boy throws out his empty hands.
The starlings jump.

Two Cemeteries

Next to the goat market
thousands of jagged slabs
stand at different angles.
No walls, so the dead
can roam about as they wish.
A stray dog sleeps against a headstone.
A young man talks on his mobile
while three others load a cow-
carcass in the boot of a car.

Overhead the blimp shaped like a bomb
beams pictures back to Washington.

A gardener prunes cherry trees
and the warden resets a headstone.
Red brick walls. You have to know the code
on the iron gate to get in or out.
The K-9 Corps walk their dogs
between lines of smart white tombs.
A steward leads a guided tour
talking through a microphone.
You can book in to come Christmas carolling.

Anacostia

a tiny red sun
like a tail light
down the overpass

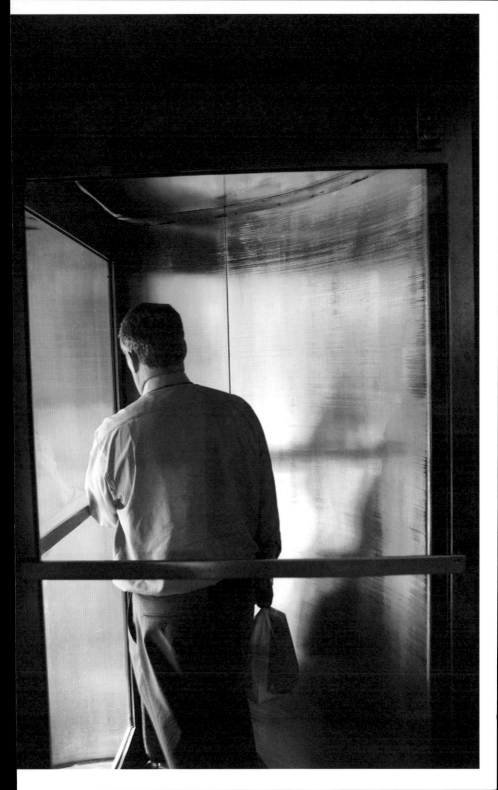

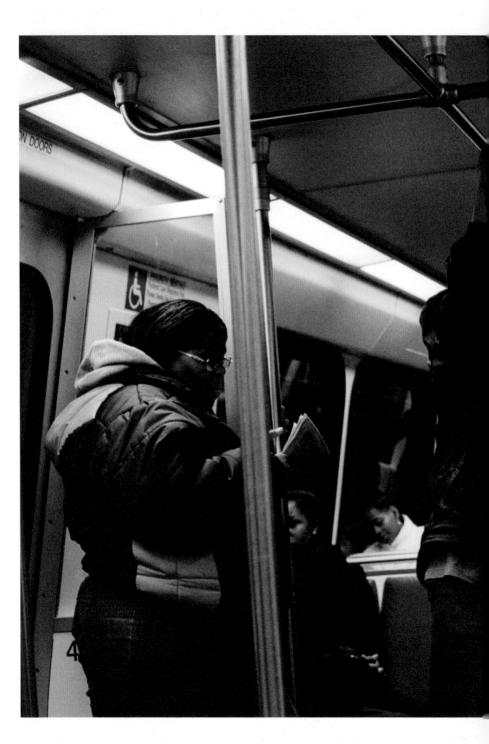

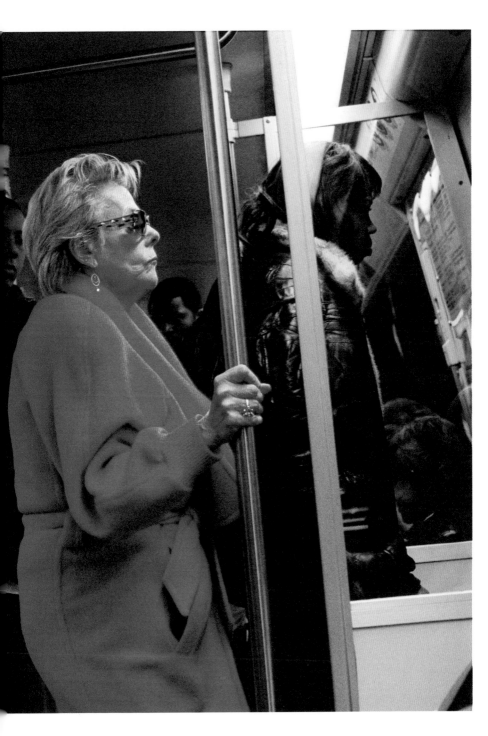

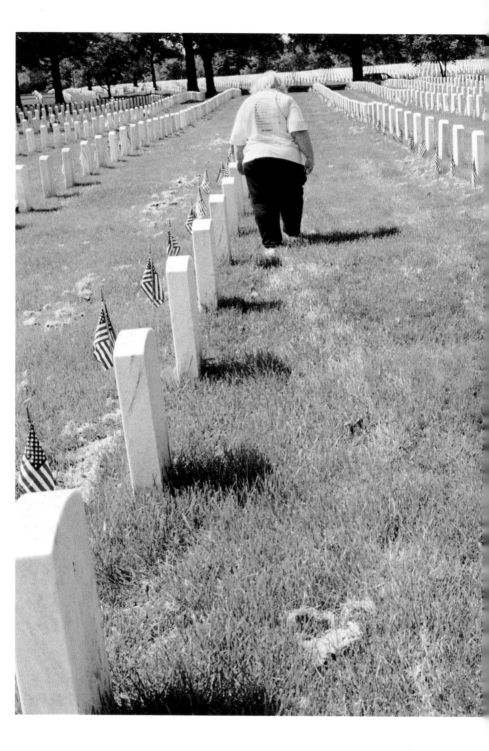

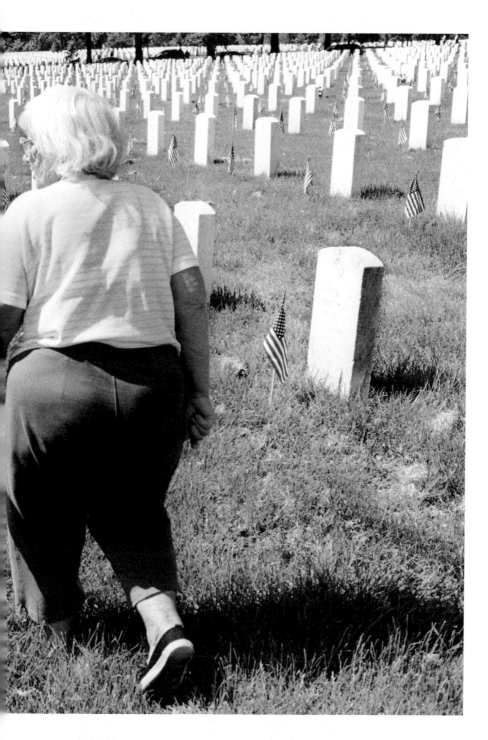

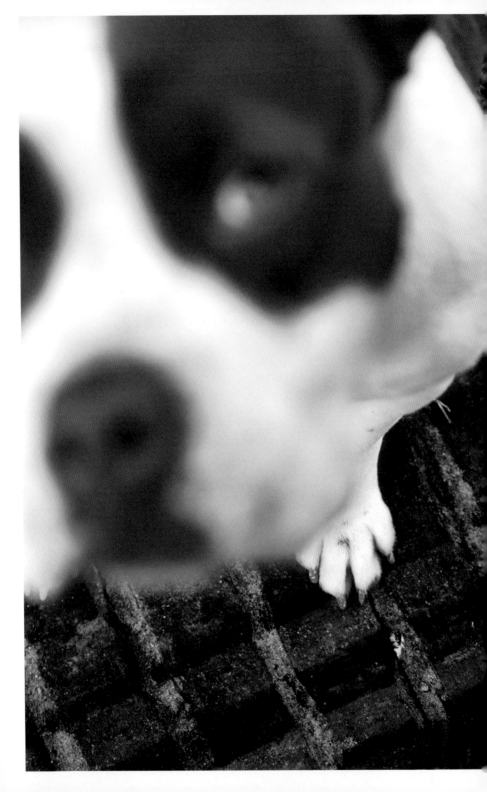

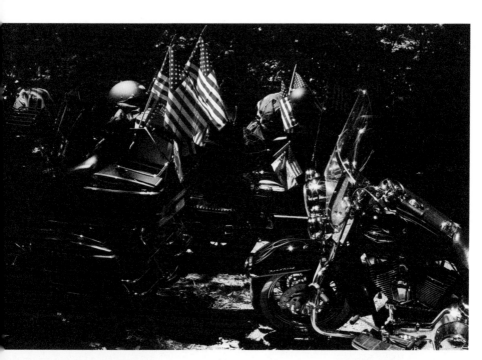

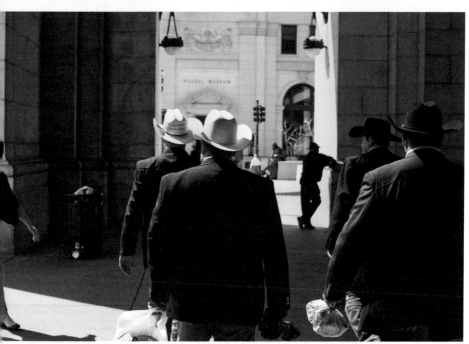

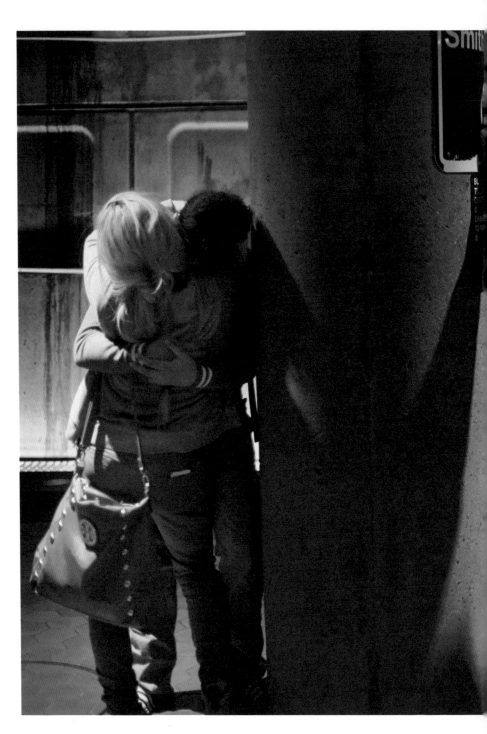

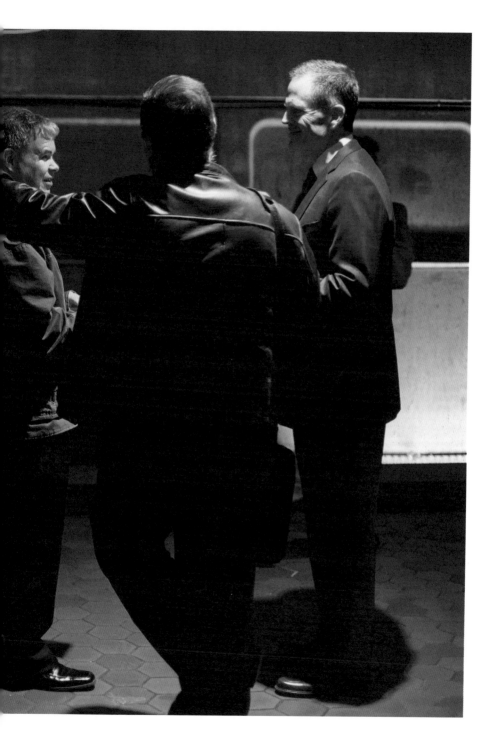

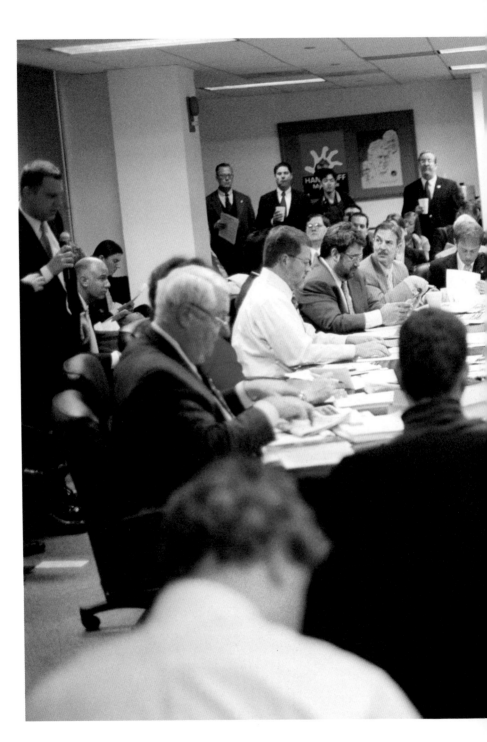

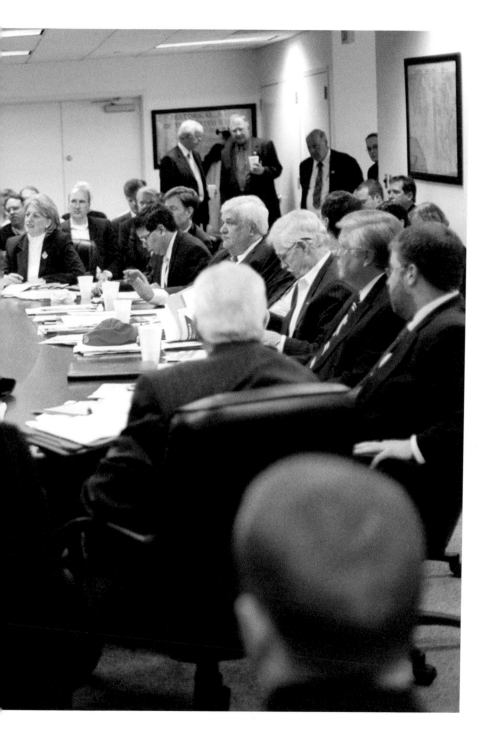

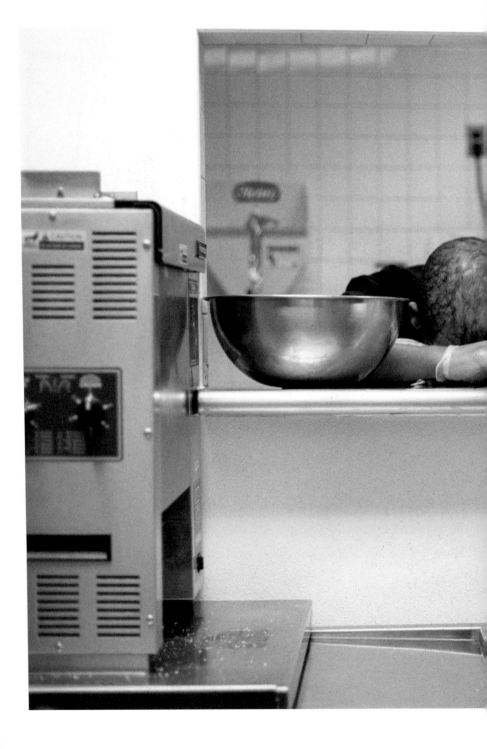

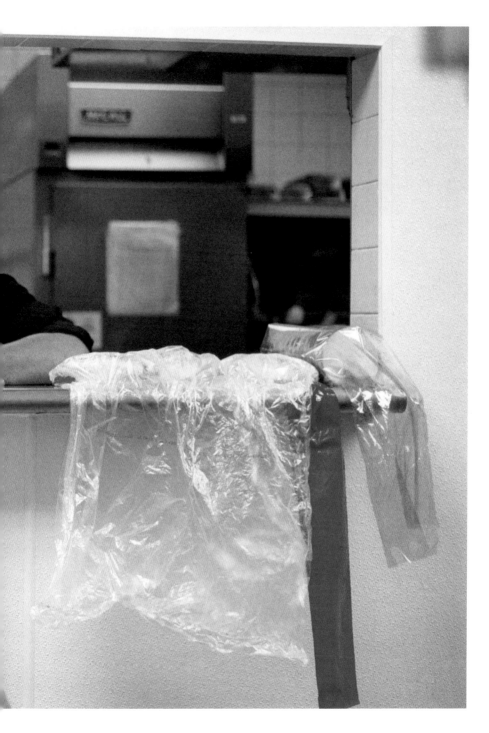

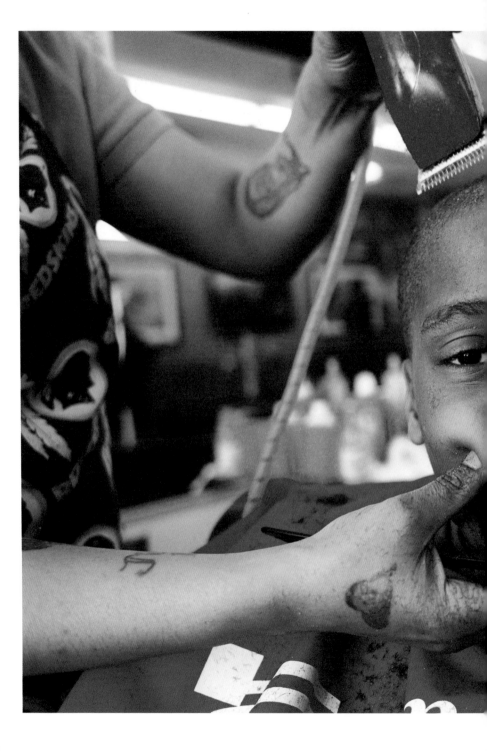

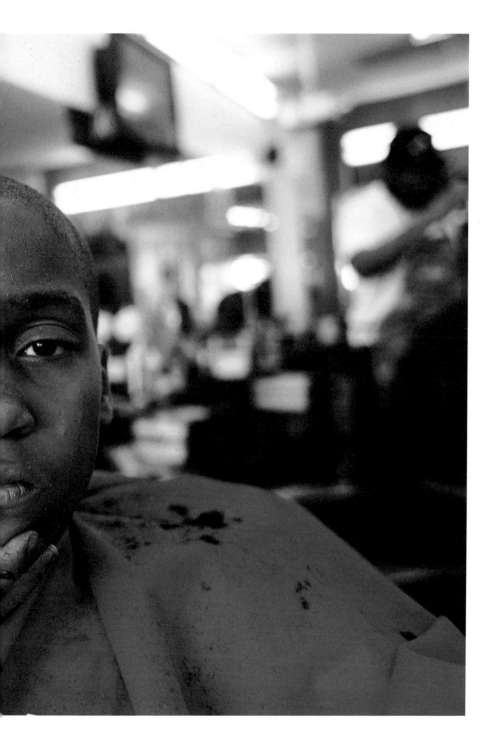

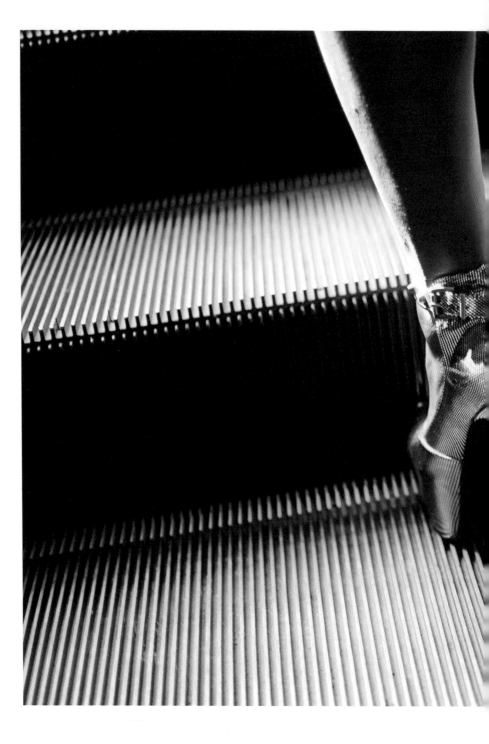

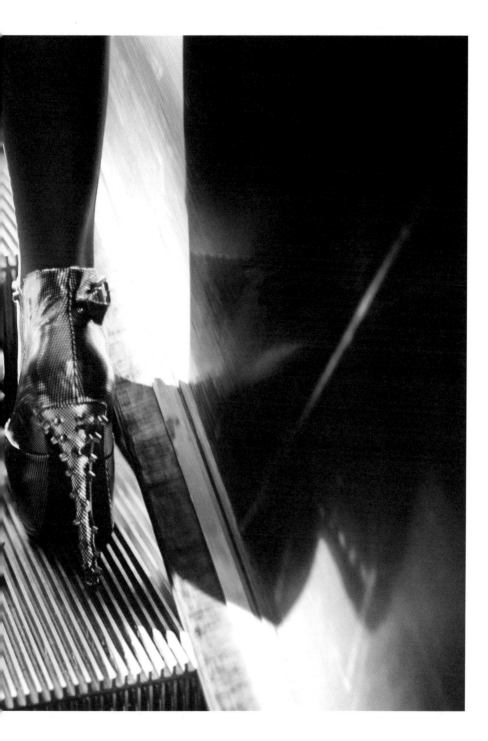

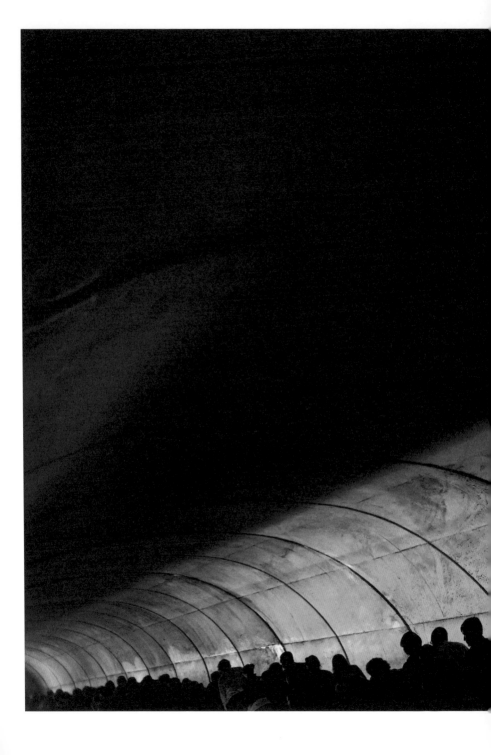

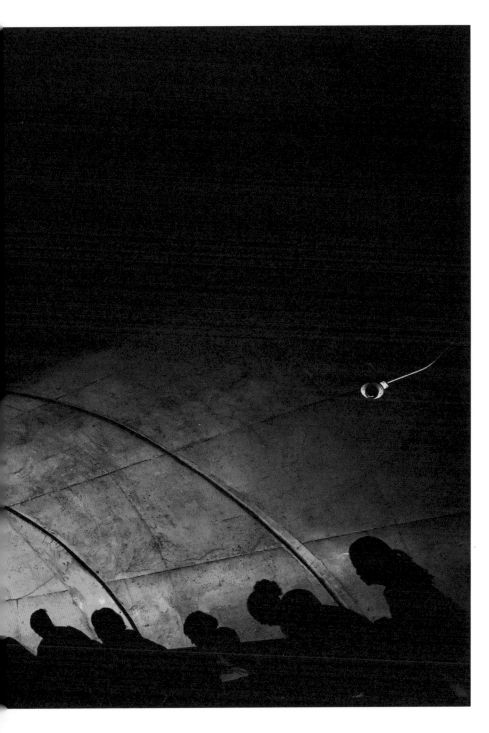

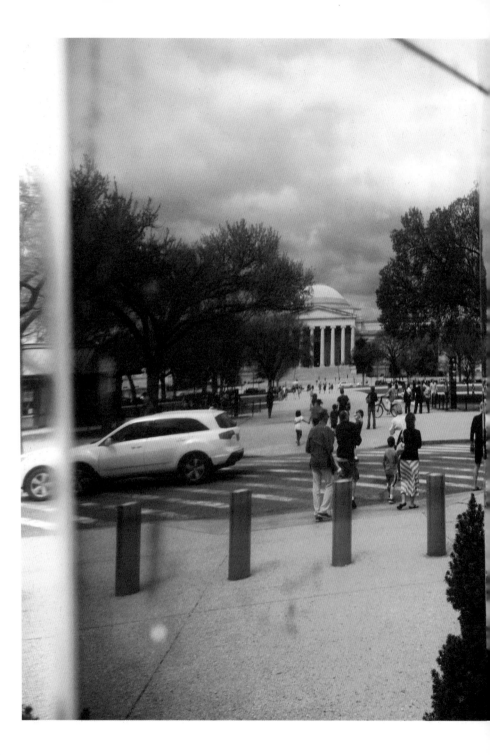

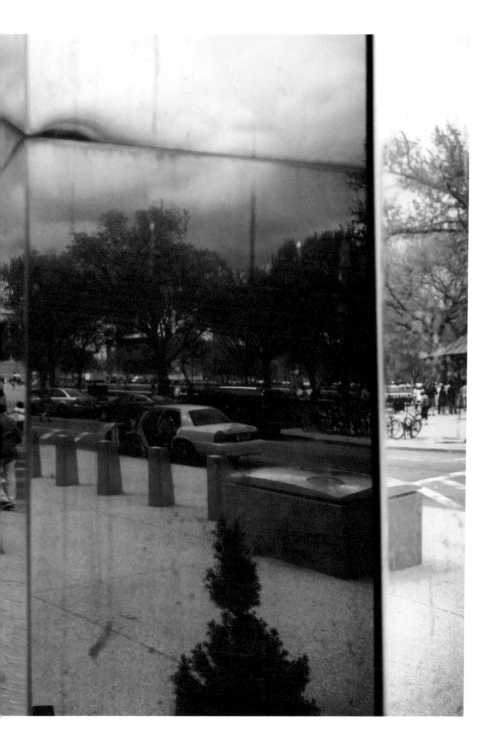

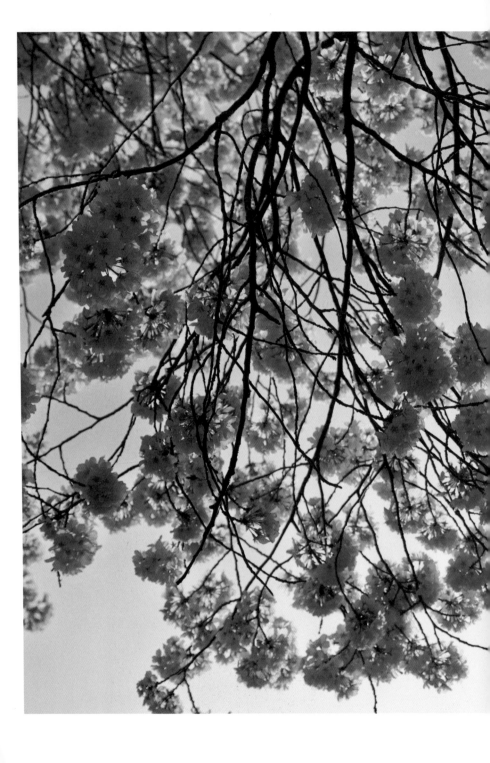

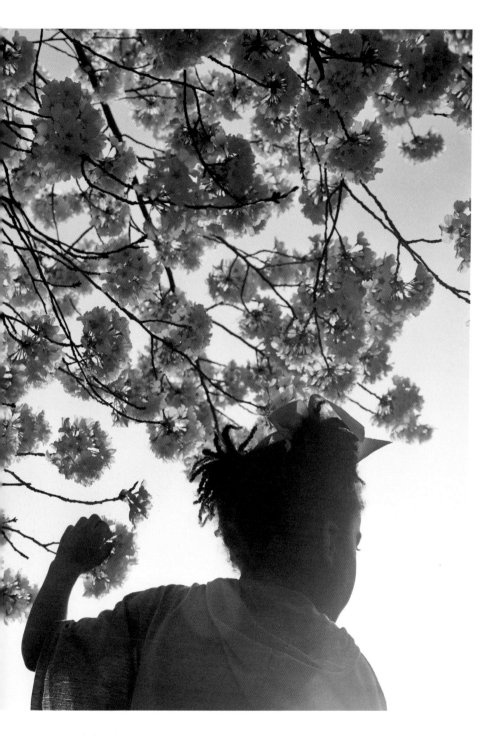

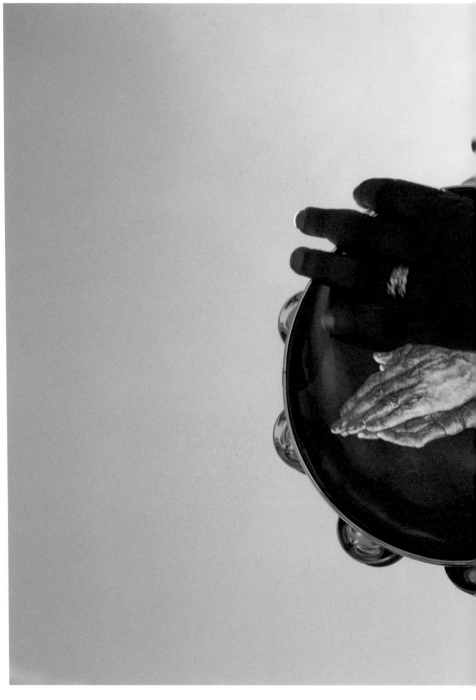

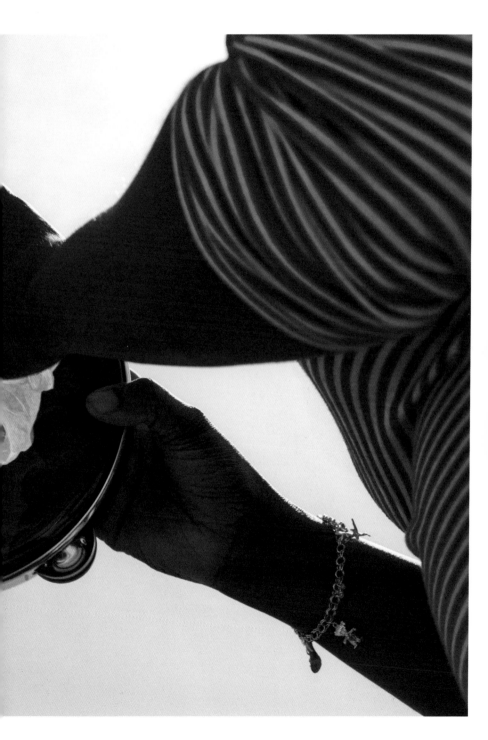

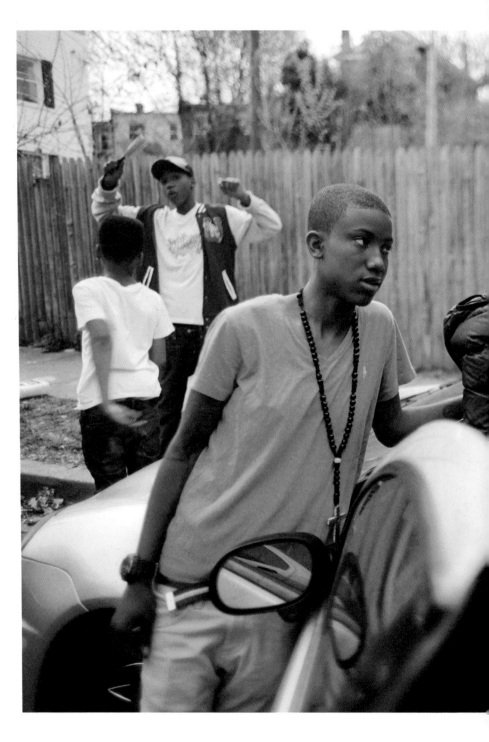

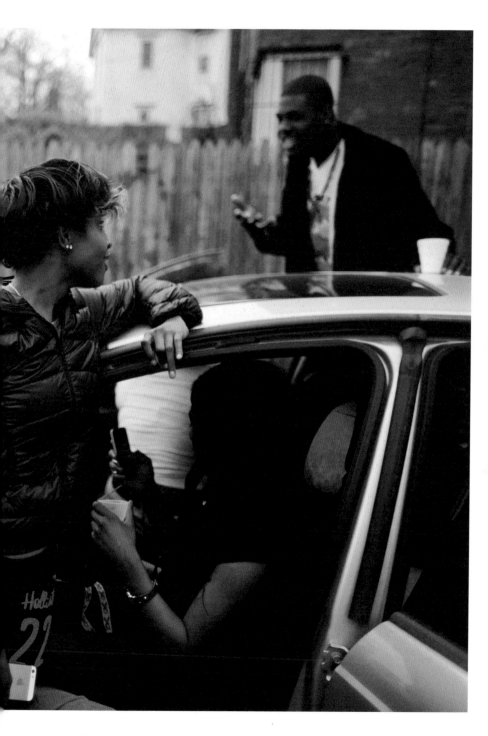

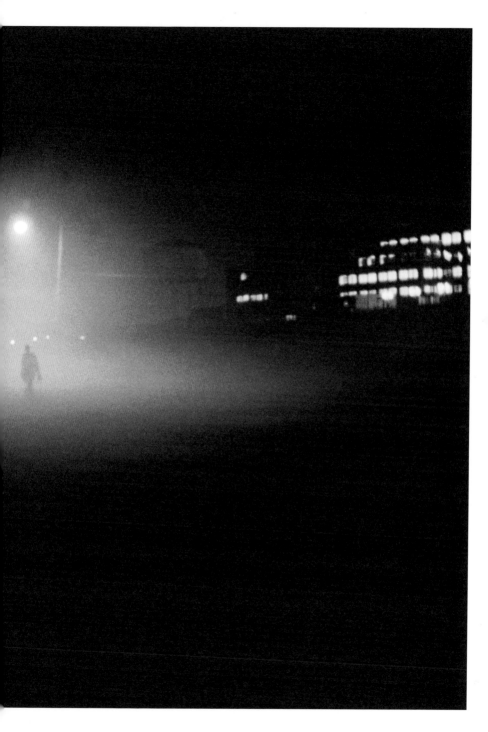

Captions

Kosovo

Afghanistan

Washington DC

*We have used the name 'Kosovo' because that is its name
in English. In Serbian it is the same, but in Albanian it is
'Kosova'. For individual places, however, we have used
both their Serbian and Albanian names.*

Acknowledgements

In Kosovo: Veton Nurkollari, Eni Nurkollari and the people at DokuFest.

In Afghanistan: the people of WADAN (the Welfare Association for the Development of Afghanistan), including Jean Kissell, Mohammed Nasib, Inayat Niazi, Rasool Sekandari and Habib Sekandari.

In Washington DC: Musa Ulusan and Paunie in Anacostia.

All of these are good friends who helped us immeasurably. They brought us deeper into the places, closer to the people.

At Bloomsbury: Alexandra Pringle, Alexa von Hirschberg, Marina Asenjo, Vicky Beddow, Hannah Temby and Jude Drake.

Special thanks to Sally-Anne McKeown.

PJ Harvey

My greatest thanks to Don Paterson for his editing and guidance, and to Greta Stoddart for her early readings, suggestions and support.

Thanks also due to Sumit Bothra, Drew Burns, Ian Cobain, Julie Collar, Jeff Craft, Ann Harrison, Michelle Henning, Jan Hewitt, Heather Lawton, Brian Message, Calum Mew, Paul Muldoon, John Parish, John Pilger, Ian Rickson, Kim Squirrel, Barry Tempest and Ben Whishaw.

Thanks to Eni Nurkollari for 'Pity for the Old Road', Paul Schwartzman for 'Sight-Seeing, South of the River', and Pops for 'A Guy Who Knows What the Fuck's Going On'.

Seamus Murphy

Binkie, Jimmie and Nuala, who live in every one of my photographs.

Smita Tharoor, who is with me always.

Jocelyn Bain-Hogg, who edited the pictures (with help from Smita and hindrance from me).

Caroline Cortizo for the care she took scanning and working with my images.

Hazel Corstens and Emma Atkinson for taking care of business.

Marie Colvin, Eliza Griswold, Tim Judah, Anthony Loyd, Charlie Sennott, Patrick Symmes, Chris Usher and Jamie Wellford for their company and good luck over the years on some of these trips.

Afghanaid, *GQ*, *Newsweek*, *Poetry* magazine, Pulitzer Center on Crisis Reporting, the *New York Times Magazine*, *The Times* and WADAN for their support along the way.

Bloomsbury Circus
An imprint of Bloomsbury Publishing Plc

50 Bedford Square 1385 Broadway
London New York
WC1B 3DP NY 10018
UK USA

www.bloomsbury.com

First published in Great Britain 2015

'The Guest Room' was first published in the *New Yorker*, 2014

British Library Cataloguing-in-Publication Data
A catalogue record for this book is available from the British Library.
Library of Congress Cataloguing-in-Publication data has been
applied for.

Limited Edition ISBN 978-1-4088-6529-3
Hardback ISBN 978-1-4088-6528-6
Trade paperback ISBN 978-1-4088-6573-6
ePub ISBN 978-1-4088-6574-3

Design by Lizzie B Design
www.lizziebdesign.com

2 4 6 8 10 9 7 5 3 1

Typeset in Plantin MT
Printed and bound in Italy by Graphicom

FSC
www.fsc.org
MIX
Paper from
responsible sources
FSC® C013123

To find out more about our authors and books visit
www.bloomsbury.com. Here you will find extracts, author
interviews, details of forthcoming events and the option to sign up
for our newsletters.